Incredible
Acrylics

Jean-Paul van Boxtel

Search Press

First published in Great Britain 2010 by Search Press Limited,
Wellwood, North Farm Road, Tunbridge Wells, Kent TN2 3DR

Originally published in The Netherlands 2008 by Tirion Uitgevers BV

Copyright © 2008 Tirion Uitgevers BV
This book is published by Tirion Art

English translation by Cicero Translations

English translation copyright © Search Press Limited 2010

English edition edited and typeset by GreenGate Publishing Services

ISBN: 978-1-84448-537-6

Layout: Biskaje, Leiden

Photography: Jean-Paul van Boxtel

Printed in Malaysia

Contents

Who is Jean-Paul van Boxtel?

From childhood, Jean-Paul van Boxtel showed a passion for drawing and painting. He started out working in photography and graphic design, a discipline that still greatly fascinates him, and then 25 years ago he added the art of painting to his repertoire. He studied at the Academy of Fine Arts in Belgium to develop his technique. His expertise is multifaceted, as demonstrated by this book. Besides being an artist Jean-Paul also teaches: he has his own small art school at his home, where students – some of whom have become permanent fixtures – have been attending his classes since 1991. Jean-Paul was also a contributor to the arts magazine *Atelier* for several years.

His wide expertise means he is very much in demand, travelling the length and breadth of the Netherlands and Belgium to lead workshops in art shops, cultural centres and art schools, including the Free Academy in The Hague. Jean-Paul also organises courses in photography and digital image manipulation. His annual 'Dordogne classes' in June and September provide inspiraton for his students in the most picturesque of landscapes. He will hold masterclasses by special arrangement which demonstrate step-by-step how to achieve a specific effect. Jean-Paul also regularly organises study tours abroad, to Italy for instance, and notably to Venice, Tuscany and Umbria.

www.jeanpaulvanboxtel.com

Preface

The power of acrylics lies in their extreme versatility. There has never been a material available that can be used in so many spheres of art. We have been waiting for this medium for centuries, and it is undeniably the medium of the future!

Thanks to its chemical composition, acrylic paints make fewer demands on the user's technical knowledge and skill than the familiar oil paints, which allows the artist to pay greater attention to the creative aspects of his or her work. I compare acrylic paint with oils simply because both can be applied in translucent as well as opaque layers; in that sense these media are quite similar. Oil paint needs to be built up from a thin ground in increasingly thicker, more flexible layers. Acrylics are not subject to this restriction: thin or thick layers can be applied on top of each other, as the artist chooses. The decorator who happens to be painting your windowsills and door jambs will say that oil-based paints are tougher and more durable. If we assume that no one is going to walk or skate across a painting too often, there is no particular advantage in it being tougher! On the contrary, the fact that acrylics do not set too hard is an advantage: acrylics will not crack – unlike oil paints – because of their permanent flexibility.

As far as colour properties are concerned, acrylics contain exactly the same pigments as oil paints, so you are guaranteed the same level of permanence, light and colourfastness. One difference lies in the surface appearance: oil paint is lustrous because of the inherent oil, while acrylic is not. This is why colours appear to be more brilliant in oil paint, but if you use a gloss medium or a shiny varnish, the difference is often imperceptible. At the workshops I give in the Netherlands, I challenge participants to point out which of the paintings I have brought with me were done in oils and which in acrylics. Often nobody can tell me. Believe me, I couldn't either if I hadn't painted these pictures myself! My advice, then, is always be open to new materials, try them for yourself, and then make your choice.

The vast potential of acrylics is demonstrated in this book by their applications in my own work. In addition I show how my paintings are built up in workshops which have been organised specially for this book. I will also shed some light on the technical aspects of acrylic paints and the specific features of gels and media. As the artist and the photographer here are one and the same person, these aspects are illustrated in a highly original manner and in a way which makes them very easy to understand.

Things to bear in mind

 A deft touch not only lowers an awkward lick of paint but is strengthened by it. In other words, there are no wrong brushstrokes!

 When you begin on a white ground, light is only created when you start putting the shadows in. Do this as soon as you can.

 Make a black and white copy of your work to look at: it gives you a better view.

 Tilt the picture every now and then.

 Look at the picture in a mirror.

 Make two try-squares from cardboard; put them together to make any size of frame and lay it over the work.

 Do not put texture gel in the layers underneath and opaque paint on top; you will lose the texture.

 If you are after optimum clarity, the best white to mix with is zinc white (transparent white or mixing white) because of its transparent pigment. However, there are not that many areas in a painting that require such clarity, and titanium white is used more commonly as it is chalkier and more opaque.

 Transparency as an application method is a different concept from transparency as a feature of a pigment.

 The three primary colours provide the broadest spectrum and also most of the greys.

 Do not glue a piece of bark from a tree on to a painting if you want to make a painting of a tree, because you will make a tree instead of a painting.

 Modelling pastes are white and will stay white when dried; colours mixed with modelling paste will be permanently lighter.

 Pay a lot of attention to the difference between transparent and opaque colours. The expressiveness of transparent colours lies in how much they reveal; you can see through the layers as long as the paint is applied transparently. In the case of opaque colours it is the top layer that dictates the effect.

 If you paint transparently you must use a white ground. Watercolours will not work on black because you need this white ground to perceive the colours. In a watercolour the white of the ground is mixed optically because it shows through the transparent layers of colour. When you use colour opaquely, then you paint the white out of the ground. Pastels are for that reason mostly mixed with white; pastel is an opaque medium. If you want to paint using an opaque covering technique, in the case of acrylics this colourless light will have to be added by mixing with white paint. In the case of opaque techniques I prefer to start on a dark ground.

 There is no connection between the subject and the way you work. Watery subjects do not by definition have to be painted in watercolours. Of course you can use watercolour if you like that medium.

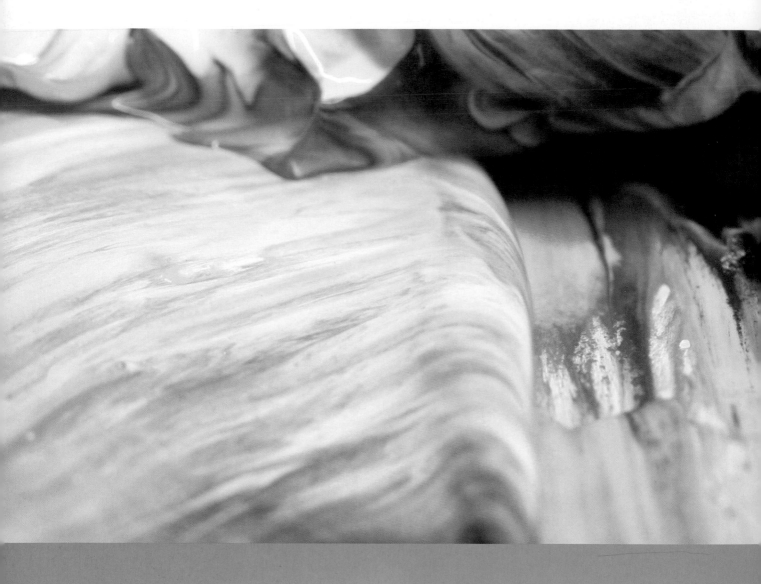

1

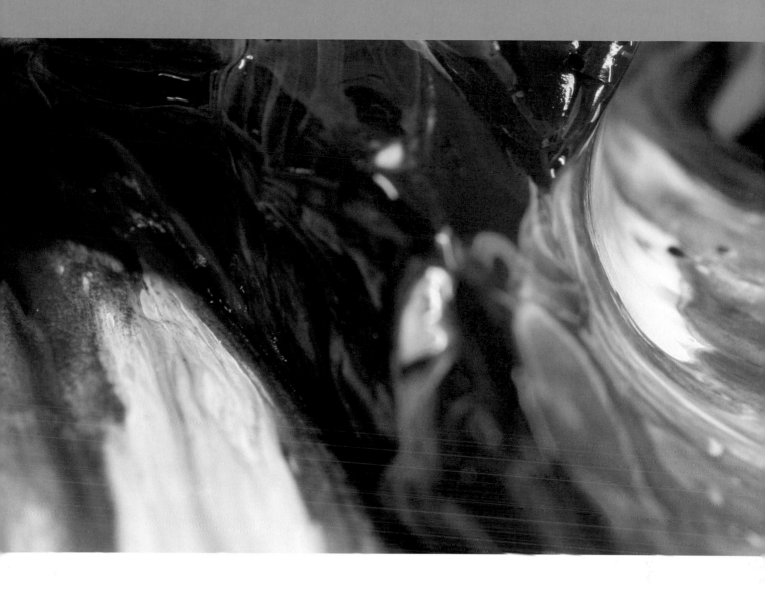

Introduction
and origins

Knowledge is power

Incredible Acrylics is aimed at artists, teachers and students at all levels.
The information in this book will help you gain a deeper understanding of the acrylic medium.
You will also be introduced to innovative techniques and applications.
The 'Frequently asked questions' chapter gives useful answers and will help to anticipate
or resolve any problems you may have with acrylic paints. The 'Applications' chapter deals
with a range of techniques and creative ideas for projects and treatments.

Back in time

In the long history of artists' materials, acrylic paint appeared quite recently. Oil paint dates from the fifteenth century. The history of tempera painting and wax paints goes back thousands of years. We have to thank prehistoric visionaries for watercolour paints. They developed the fundamental model for paint which still serves us today: a combination of pigment (coloured earth), a medium (or spittle for the very first artists) and a binding agent (fat obtained from prehistoric animals).

Acrylic paint was originally developed as a medium borne in a solution at the start of the twentieth century. The first waterborne acrylic paint was developed and launched in 1955 and is the type that we still use today. Permanent Pigments, a company based in Cincinnati, Ohio, USA, launched a new product in that year. This company had been making oil paints since 1933 and was owned by Henry Levison, a man who lived, breathed, drank and slept with artists' paints. His new paint used an acrylic polymer resin as a medium, which made an emulsion when it was mixed with water. The new paint could be thick or thin or anything between; it adhered to just about everything, from canvas to paper, to metal and wood, and even to plastics. It dried quickly and made overpainting, working in layers and painting with masks easy. However, the crucial thing was that it could be thinned and wiped off with water. Levison persuaded some artists to try the new product, but acceptance was slow.

Acrylic paint was only genuinely accepted when Levison discovered a principle that still applies: good information is at least as important as good materials. On the basis of this, he launched a programme of lectures and demonstrations. Artists started to give workshops and lectures on works painted in acrylics to students and teachers in art schools, and after a few years academies across the United States were using nothing but acrylic paint. Not long after this, some of the most important artists of the second half of the twentieth century, such as David Hockney, Helen Frankenthaler, Andy Warhol and others, started to use acrylic paint. We could say that twentieth-century art would have been very different without the working properties of waterborne acrylic paint.

By the 1980s, acrylics had grown into the most popular and widely used painting medium. Acrylic had left watercolour as well as oil paint far behind. It goes without saying that there is no paint more versatile anywhere in the world. Whereas the success and stability of watercolour and oil media can only be guaranteed by a careful selection of grounds and techniques, acrylics can be used with very few directions on virtually any ground and for practically any optical or sculptural purpose. Acrylic paint can be applied to canvas, paper, fabric, leather, metal and wood with a brush or a palette knife, by spraying, pouring or dripping, and with scraping and cutting techniques. In short, with a little care and the correct additive or medium, acrylic paints can do anything you can imagine.

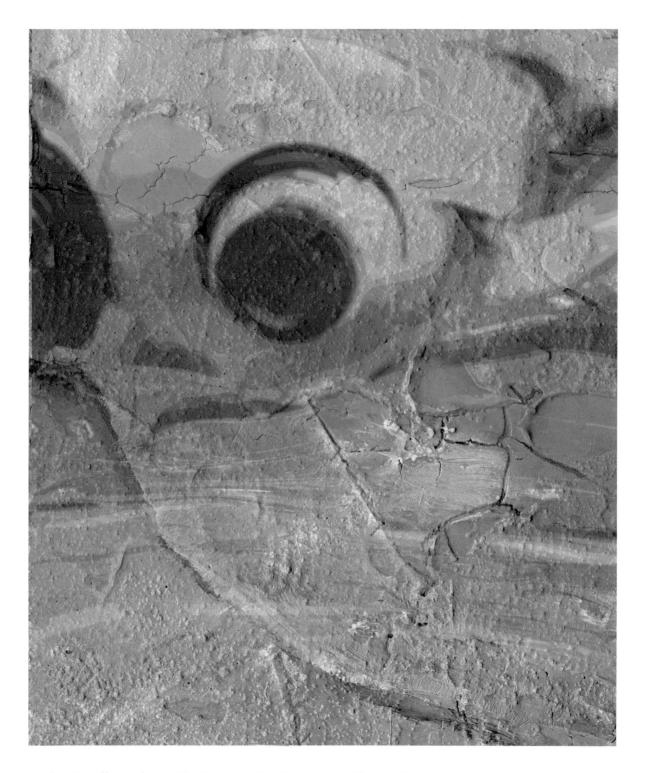

Acrylic paint offers such versatility because it has three very special properties:

1 It sticks. To almost everything. Acrylic paint adheres phenomenally well to all kinds of grounds.
2 It bends. After it has dried, and even a long time later, acrylic paint retains its elasticity much better than oil paints. It can therefore be used on many more different types of ground without cracking.
3 It is flexible. Thanks to the miracles of modern chemistry, the processing properties of acrylic paint can be modified, adapted and mastered in an infinite number of ways. A basic understanding of the chemistry of acrylic paint is useful if you want to get the most from this versatility.

2

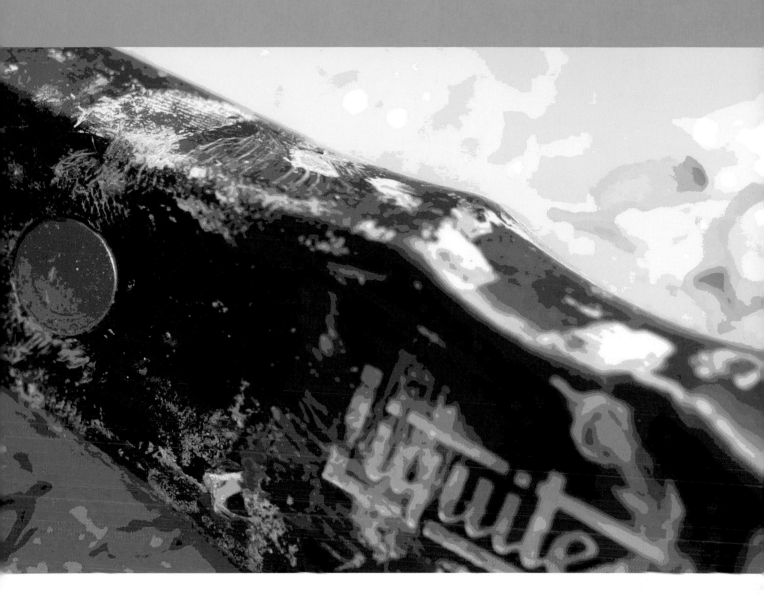

Essential information

What is acrylic paint?

Waterborne acrylic paint consists of pigment particles that are very finely distributed in an acrylic polymer emulsion. The 'Frequently asked questions' section gives useful answers and will help to anticipate or resolve any problems you may have with acrylic paints. The 'Applications' section deals with a range of techniques and creative ideas for projects and treatments.

Ingredients of acrylic paint

Pigment

- A type of dry powder that does not dissolve when mixed with acrylic polymer emulsion and remains suspended in the mixture. Pigments can be organic, inorganic, natural or synthetic. They have little or no relationship to the ground on which they are applied.
- Carrier (vehicle). A mixture of water and acrylic polymer, which together form a polymer emulsion. As soon as the water leaves the mixture by evaporation or absorption, the paint dries. A stable layer is created in this process that will permanently fix the pigment particles.

- Binding medium.
- Acrylic polymer without water. The binding medium determines the working properties and the durability of a paint.

Clarification

- Polymer

A 'polymer' is a long chemical chain of smaller, often identical molecules. When it has completely joined, it forms itself into a tightly ordered structure that potentially ensures strength and stability. In acrylic paint a stable polymer structure keeps the pigment in its place.

● Emulsion

A mixture of water and acrylic polymer. An emulsion is a stable mixture of ingredients which would normally not mix properly. (You can, for example, mix oil with water but they will always revert and separate from each other.) In order to force water and acrylic polymer to remain a stable mixture until the water has evaporated or been absorbed, chemical emulsifiers are added.

How acrylic paint works

Acrylic paint dries because water evaporates. When pigment, water and acrylic turn into a paint layer that can stand the test of time, the following happens.

STEP 1

When it comes out of a tube or pot, acrylic paint is a carefully balanced dispersion of pigment in an emulsion of acrylic polymer and water. The water keeps the emulsion fluid and is a type of chemical 'watchdog' which prevents the acrylic polymer particles from coming too close and sticking together for good, before the artist has finished.

STEP 2

The water in the emulsion evaporates when it is exposed to the air or absorbed by the ground. The acrylic polymer particles will then come into contact with each other and fuse.

STEP 3

The polymer particles organise themselves into a stable, hexagonal structure which traps the pigment. Bingo! A stable paint layer.

In the diagrams below, an empty circle in Steps 1 and 2 is a polymer, while the small black circle is the pigment.

Make sure that you never dilute acrylic paint with more than 25 per cent water. This is very important, as too much water spreads the acrylic resin so thinly that it cannot form a stable layer. The addition of an acrylic medium instead of water will prevent this and guarantee the stability of the paint layer. Acrylic–water emulsion looks milky when it is wet, but is crystal clear when it is dry. This milky effect makes the colour a little lighter. When water leaves the emulsion and the medium becomes clear, the colour becomes a little darker. This change in colour is normally referred to as the colour shift from wet to dry and is most obvious with dark transparent pigments (such as alizarin). This is less visible with light opaque pigments (such as cadmium yellow). With the advance of chemistry, new acrylic resins are now available to us from all parts of the world and are brighter than ever before when wet.

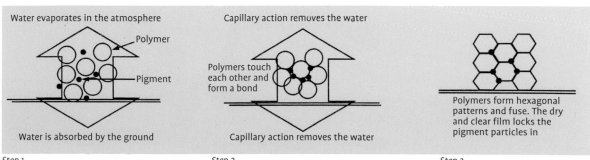

Water evaporates in the atmosphere
Polymer
Pigment
Water is absorbed by the ground

Capillary action removes the water
Polymers touch each other and form a bond
Capillary action removes the water

Polymers form hexagonal patterns and fuse. The dry and clear film locks the pigment particles in

Step 1 *Step 2* *Step 3*

Properties of acrylic paint

Basic features

- Soluble in water as long as it is wet.
- After drying it becomes a permanent, flexible paint film that is insoluble in water. Thick layers are not sensitive to cracking or flaking, with the odd exception, of course. It is less flexible in cold weather, softer in warm weather.
- It can, if necessary, be thinned with a minimal amount of water. Always use acrylic media to modify the flow and working properties and to maintain the stability of the final layer of paint.

- Do not mix with solvents, turpentine or oil. Only mix with different acrylic emulsion paints or media.
- Keep all brushes wet. Clean brushes, hands and palette with water and soap.
- Low odour, no vapours, non-flammable.

NB About flexibility: although acrylic paint and acrylic media remain flexible for a long time, every acrylic paint layer becomes more brittle in cold weather. Therefore avoid bending, rolling or unrolling acrylic paintings at temperatures below 7°C (45°F).

Drying properties

- Acrylic paint dries through the evaporation of the water it contains. Thin paint layers dry within ten to twenty minutes, while in the case of thick paint layers this can take between an hour and several days.
- On a porous ground the water evaporates both via the paint layer and the carrier.
- Resin particles fuse together and capture the pigment as the water evaporates; the polymer resin bonds and roughly assumes a hexagonal shape. When this process is complete, there remains a waterproof, flexible paint layer that will not yellow.

Removing acrylic paint

- From the hands: wash off wet and dry acrylic paint with water and soap.
- From large and small paintbrushes: clean wet brushes with water and soap. Clean dried acrylic paint from tools with acetone, white spirit or a similar product. These cleaning substances are toxic. Treat them with care.
- From clothing: wash paint that is still wet from the fabric using water and/or window cleaner. Dried acrylic paint cannot be washed out.

- From the paint ground: wipe away paint that is still wet with a damp cloth and wash off with water. Dry paint can simply be painted over. The surface of a dry acrylic painting can be cleaned by carefully washing off with water and soap.

Essential things to know about acrylic paint

- Good products will contribute to your success. Good quality paint gives vivid colours, the purest colour where it is needed and everything that is essential for creative, artistic success.
- Artists' paints are expensive. They cost more than hobby paint because of the price of the pigments. Acrylic paint has an extraordinarily high pigment content.
- Artists' paints are sold and priced in 'series'. The price level of each series reflects the relative costs of the unique pigment used to make the paint.
- Acrylic paint can be produced with various levels of viscosity ('body').
- Acrylic paint is ideal for contemporary and experimental applications. The paint dries very quickly (it remains workable for ten to forty minutes) so is very suitable for techniques where masks are used, where successive layers are applied rapidly and for textured layers.
- It is ideal for murals, textiles, tiles and textured techniques.
- Acrylic paint can also be used for traditional painting techniques. With the use of media the paint can be made suitable for glazing, impasto, watercolour and other techniques.
- Acrylic paint can be used on virtually any ground: from paper and canvas to stone and wood. The only exceptions are shiny surfaces. Plastic needs to be keyed (abraded) before painting; leather must be degreased with alcohol. Always try a sample first to test the adhesion if you are using an unusual ground.

Label information

The packaging usually gives information about the characteristics of the paint it contains. This varies from brand to brand.

- **Transparency**
 The transparency and opacity (covering power) of paint are related to the characteristics of the pigments that are used.
 – Opaque. In the case of opaque colours, the paint layer does not allow any light through.
 – Semi-transparent. This is between transparent and opaque. The paint layer does let some light through, but is not really transparent.
 – Transparent. Transparent colours really let light through. They 'cover' least. The underlying colour remains visible through the paint layer. They are most suitable for glazing and watercolour techniques.
- **Permanence and colourfastness**
 Colourfastness tells us to what extent a colour resists fading or discoloration on exposure to ultraviolet light (for example sunlight).
- **Pigment compounds**
 This may state whether the paint consists of one or more pigments.
- **Price category**
 Often the packaging also states the price category to which a specific colour belongs: series 1, series 2, etc. Certain pigments are simply more expensive, for example cadmium and cobalt.

Mixing colours: minerals and 'modern' pigments

In order to achieve good colour mixtures, it is essential to have an understanding of the pigment used for each colour. Each pigment has different characteristics and these also influence how pigments react to each other. The unique optical characteristics can range from transparent to completely opaque. Some pigments have a lot of tinting ability and give fresh and clear colours. Others have a tendency to turn somewhat grey when mixing colours.

Mineral pigments such as yellow ochre and raw umber have been used since prehistoric times. A wide variety of other mineral pigments became available in the nineteenth century; industrial and chemical developments at the time made it possible to combine metals such as cadmium and cobalt with different substances. The results were very stable, much less likely to fade and could be ground into a suspension in a medium for oil paint. More recently, pigment chemistry underwent a revolution when 'new' organic colours were born in the laboratory. This resulted in the appearance of pigments such as anthraquinones, dioxazines, pyrroles, phthalocyanines and benzimidazolones. These provide the vast variation in colours available to contemporary artists.

SOME SUGGESTIONS FOR COLOUR PALETTES

Palette of three primary colours with white:

- quinacridone crimson (primary red)
- yellow medium azo (primary yellow)
- phthalocyanine blue (primary blue)
- titanium white

Palette of four cadmium-based colours with white:

- quinacridone magenta
- cadmium red light
- cadmium yellow medium
- phthalocyanine blue (green shade)
- ivory black
- titanium white

Palette of four colours of substitute pigments with black and white:

- quinacridone magenta
- cadmium red light hue
- cadmium yellow medium hue
- phthalocyanine blue (green shade)
- ivory black
- titanium white

3

Products

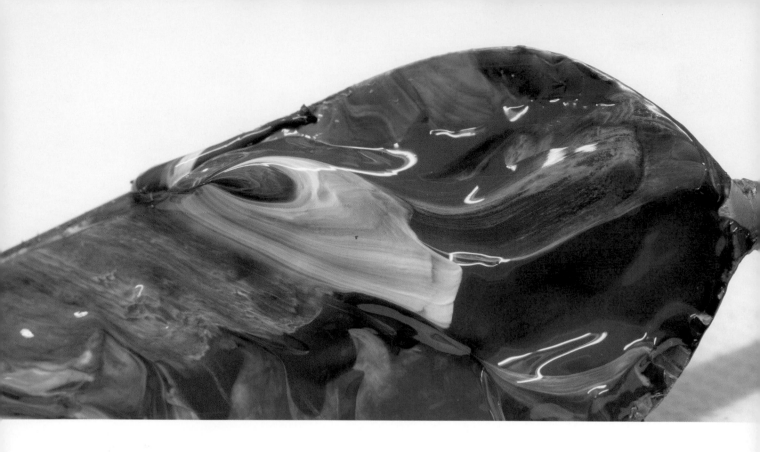

Paint

Since the development of the first waterborne acrylic products for artists in 1955, paintmakers have attempted to satisfy the wishes and needs of professional artists. The formulas for all products are put together by a unique team. This includes chemists with knowledge and experience in the area of resin technologies, and artists, who help the team to stay focused on improving the working properties of paints. Together they create versatile ranges of some of the most powerful, durable and strongly pigmented paints in existence. Various viscosities are available in student paints and in those for the professional sector. The paint is flexible when dried, hardwearing, UV-resistant, waterproof and pH-neutral. All acrylic brands and all media can be mixed together.

Thin paint

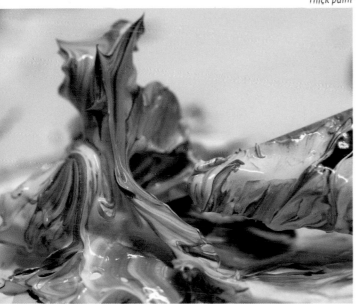

Thick paint

Professional paint

THIN PAINT
Here mixed with:
cadmium yellow medium hue
naphthol red light
quinacridone magenta

THICK PAINT
Here mixed with:
ultramarine blue (red shade)

VERY THICK PAINT
Here mixed with:
quinacridone magenta
cadmium yellow medium hue

Properties
- Little or no perceptible colour shift from wet to dry.
- Wide range of intense, permanent pigments.
- Every colour has a unique composition, in which the tinting ability and purity of every separate pigment has maximum impact.
- The formula ensures that after drying, all colours have a satin sheen within a narrow range.
- Suitable for interior and external applications.
- Water-soluble in wet state, drying quickly to an impermeable surface.
- No chemical drying to extend the painting and varnishing process.
- Excellent adhesion to most paint grounds: wood, leather, canvas, silk, plastic, walls, metal, paper, etc.
- From a chemical point of view, acrylic paint is alkaline when wet and can therefore be used on normal surfaces for murals, such as concrete, plaster, cement, concrete blocks or brickwork.
- Resists ultraviolet light, does not yellow and will not become brittle in the long term.
- Exceptional colour clarity and shine for brilliant mixed colours.

Very thick paint

Student paint

Here mixed with:
phthalocyanine blue (red shade)
quinacridone magenta
naphthol red light

Student paint has been developed for students and artists who require reliable quality at an affordable price. Every colour has its own unique formula, in which the tinting ability and colour clarity of the pigments it contains are maximised. The pigment content is less, however, than with professional acrylic paint.

Today there is a selection of different viscosities in both the professional range and in student paint. There is thin, fluid paint, but one can also go for thick and even very thick paint.

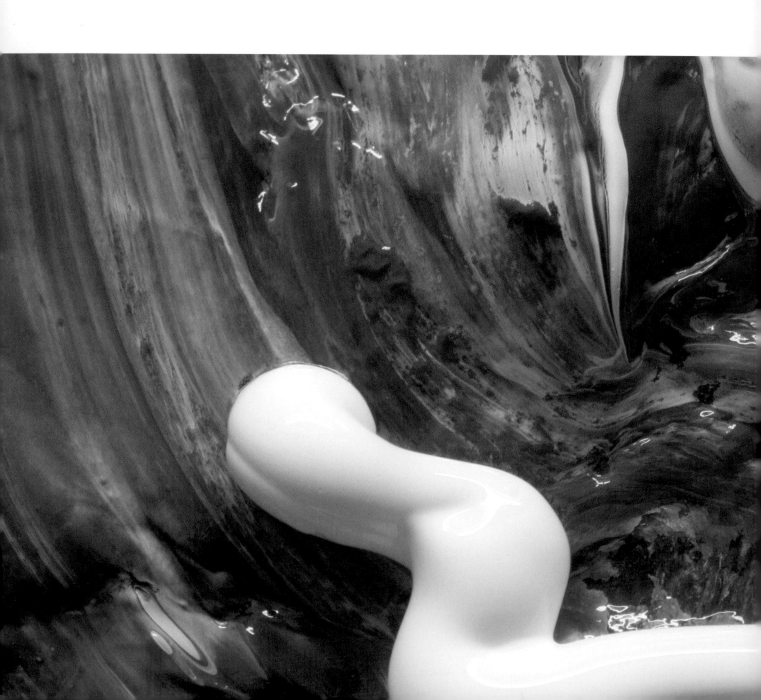

Media

To inspire creativity at every stage in the painting process, there is a huge range of acrylic media, which can be used alongside the entire range of professional and student-quality paints. Media can be classified under three headings: preparation, painting and finishing.

Preparation

Preparation reduces the absorption of virtually every ground while its grain (or key) increases. This lays the basis for the stability and durability of the paint layers that are applied to the ground. With five different products, the right preparation medium (or sizing) is available for every type of work.

Painting

When you are painting you can use all kinds of other products along with the paint itself, such as fluid media, gel media, additives and texture gels. Each of these products will be discussed individually later on in this book. With these media you can alter the painting and optical properties of the paint in such a way that you can make use of an extraordinary variety of painting techniques.

Finishing

Varnish applied to a completed painting gives the surface a uniform degree of shine and protects the paint layers against environmental influences and ultraviolet light. You can obtain the right medium to achieve any desired result, from preparing the ground and painting your masterpiece to applying the finishing touches. Try to find out what mixing acrylic paint with one of the many media offers you in the way of new possibilities.

Essential information about the use of acrylic media

- For the best results, always test before using.
- Mix media with acrylic paint for improved flexibility, adhesion and long-term stability.
- Media increase the volume while most of them also increase the transparency of the acrylic paint.
- The drying time for a thin layer of medium (1.5mm/¹⁄₁₆in) can vary from thirty minutes to twenty-four hours, while a thicker layer (6mm/¼in) will only feel dry after two to five days.
- Using an atomiser or humidifier will increase the drying time of all media.
- Avoid grounds that contain oil, grease, wax or oil paint.

- When painting on a hard or smooth ground, such as glass, metal, enamel or hardboard, first abrade (or key) the ground to improve adhesion before applying the medium.
- If you apply forceful brushstrokes over textured sections, bubbles of air may form in the paint layer.
- Do not work too long on the paint itself. If you rub over the media while they are drying, they may become patchy. Once the paint layer has become patchy, it cannot be changed when dry. In this situation allow the paint layer to dry and then apply a new layer of medium on top of it.

General points

- Most acrylic media are made of 100 per cent acrylic polymer emulsion which will form a durable layer on drying. They are in fact colourless paints. They are the binders (glue) for acrylic paint, with excellent flexibility, and are extremely resistant to chemical influences, water and ultraviolet radiation.
- Acrylic polymer emulsions are added to acrylic paint to change the working properties, the appearance or the volume and generate an infinite variety of effects.
- Media are available in various viscosities, often both gloss and matt. They can all be mixed with each other.
- They can contribute to all kinds of applications and techniques. Sometimes you need to combine various media to achieve the desired effect. Different media can also be used separately to achieve similar effects.

Preparation

Painting

Finishing

White gesso

Clear gesso

Preparation/sizing

GESSOS

White gesso

This is the classic white separation layer and ground for absorbent grounds such as canvas, paper or wood. It gives the surface the sizing, key (so the paint adheres well) and absorption necessary for acrylics and oil paints. One layer is usually enough. If you go for several layers, then it is preferable to abrade each one before applying the next. Traditional gesso must be opaque titanium white for good coverage (opacity).

Properties

- Traditional white size and ground paint.
- Excellent ground for acrylics and oil paints.
- Can be mixed with acrylic paint for a tinted ground.
- Very opaque.
- Flexible, will not crack or yellow after drying.
- Gives the perfect key and adhesion for a wide variety of grounds such as canvas, paper and wood.
- Excellent basis and ground for many techniques and applications.

Application

- For canvas, paper, wood and all clean, porous and non-greasy grounds.
- Sizes, prepares and so creates a good ground for a preliminary sketch in charcoal or in pencil.
- Use undiluted or thin down with a maximum of 25 per cent water.
- In the case of dilution greater than 25 per cent, use a mixture of equal parts water and matt medium to thin the gesso.

Clear gesso

A crystal-clear size and ground which ensures that the colour of the ground remains visible. It gives an ideal key for pastel, wax crayon, graphite and charcoal, and is also an excellent ground paint for acrylics and oil paint. Clear gesso is ideal for painting on a coloured or patterned ground or when using a base sketch. Mix it with a transparent acrylic paint for a transparent tinted ground. Will dry transparently or semi-transparently, depending on the thickness. One layer is usually enough.

Properties

- A clear size and ground paint through which the substrate remains visible.
- Ideal key for pastel, wax crayon, graphite and charcoal.
- Excellent ground for acrylics and oil paint.
- Mix in acrylic paint for a tinted ground.
- Dries clear to translucent, depending on the thickness.
- Flexible, will not crack or yellow after drying.
- Offers the perfect grain and adhesion for all kinds of ground, such as canvas, paper and wood.
- Excellent base layer and ground for many techniques and applications.

Application

- For canvas, paper, wood and all clean, porous, non-greasy grounds.
- Sizes and grounds while retaining the original appearance of the ground.
- Gives paper a good key for chalk and wax crayon techniques.
- Mix with a little bit of (semi-)transparent acrylic paint to give the ground a colour while still retaining transparency.
- Do not work up too much with the brush.

Super heavy gesso

An innovative, pasty, titanium white gesso which can retain a sculpted shape. It has all the properties of traditional acrylic gesso. It is ideal for building up thick, sculptured shapes with a knife or brush.

Properties

- An innovative, pasty acrylic gesso for preparing grounds for acrylics and oil paints.
- Build up thick sculptural shapes.
- Mix with acrylic paint for a tinted ground.
- Flexible, will not crack or yellow after drying.
- Gives the perfect key and adhesion for all kinds of grounds such as canvas, paper and wood.
- One layer is usually enough.

Application

- For canvas, paper, wood and all clean, porous, non-greasy grounds.
- Use with knife or brush.
- Do not abrade.

Black gesso

A tinted preparation medium with all the properties of traditional acrylic gesso. Some artists prefer to start on a tinted ground to explore the painting process from a different angle. One layer is usually sufficient. Black gessos cover the ground with a non-transparent layer, just as traditional gesso does.

Properties

- Excellent ground paint for acrylics and oil paint.
- Will not yellow.
- Flexible, does not crack.
- Gives the perfect key and adhesion for all kinds of grounds such as canvas, paper and wood.
- Excellent base layer and ground for many applications, such as murals.
- One layer is usually enough.

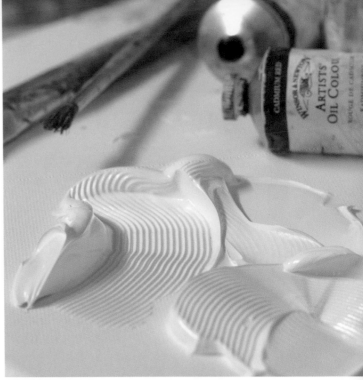

Super heavy gesso

Black gesso

Application

- Good size and ground for underdrawing in pastel (pencil).
- Use undiluted or thin down with a maximum of 25 per cent water.
- In the case of dilution greater than 25 per cent, use a mixture of equal parts of water and matt medium to dilute the gesso.
- Can, of course, also be mixed with white gesso.

Painting

When you are painting you can use all kinds of other products along with the paint itself, such as fluid media, gel media, additives and texture gels. You can vary the working and optical properties of the paint in such a way that you can make use of an astonishing range of painting techniques.

FLUID MEDIA

Fluid media have a (thin) liquid character. They reduce the viscosity of heavier types of paint and gel and have a tendency to smooth out and eliminate brushstrokes. Fluid media modify acrylic paint in all kinds of ways and include acrylic resin, which maintains or promotes its adhesion and durability.

Fluid media
- Improve flow.
- Dry transparently or semi-transparently.
- Increase the volume of (thin) paint.
- Form an excellent lasting size for collages.

Significant properties
- Fluid media level out and create a paint layer without visible brushstrokes.
- Mix with thin paint to retain the viscosity of the paint.
- Mix with thick paint to reduce the viscosity of the paint.

Do not shake fluid media, otherwise they will become frothy. Froth can seriously affect the transparency of the paint layer and make it patchy or cloudy.

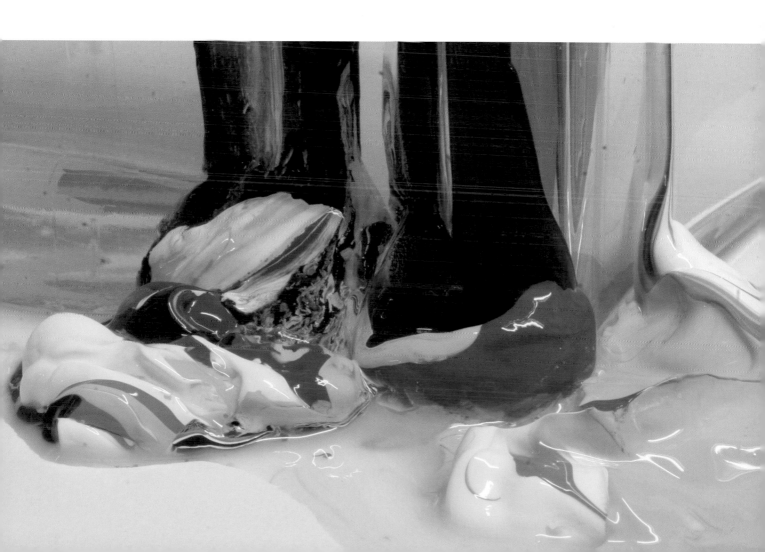

Glazing medium

Here mixed with:
quinacridone magenta
phthalocyanine blue (green shade)
burnt sienna
naphthol red

Use glazing medium if you need maximum transparency to give paintings more light and depth. Creates sparkling glazes when mixed with transparent colours. Glazing medium dries quickly – enabling you to put several layers on top of each other – and does not retain (or hardly retains) brushstrokes. To increase working time, mix with slow-dry blending medium.

Properties

- To create brilliant glazes with strong colours using acrylic paints.
- Excellent for brush technique, smooths out very well.
- Dries quickly, enabling rapid application of successive layers.
- Small quantities of paint give the greatest transparency.
- Works best with transparent or translucent colours.
- Flexible and waterproof on drying, will not yellow.
- Crystal clear when dry.

Application

- Can be mixed with any quantity of acrylic paint.
- Apply to dry, painted areas to modify the colours without losing the detail underneath.
- Previous layer must be totally dry before the next layer is applied.
- Mix a small quantity of paint well with the medium and the colour will become lighter. The medium will dry transparently, after which the colour will appear darker in the form of a thin, transparent version of the original colour.

Gloss medium & varnish

Here mixed with:
raw sienna

Both a glossy medium and a varnish: the workhorse of the media range. This universal medium can be used as a shiny varnish and/or as a glossy fluid medium. This improves the adhesion of the paint layer and increases the depth, intensity and brilliance of the colours. Excellent for transfers of printed work.

Properties

- Universal medium with a formula that allows for mixing with all acrylic paints and media.
- Can be mixed with any acrylic paint for deeper colour intensity; in order to increase the transparency, brilliance and flow of the paint; and to render the paint layer flexible and improve adhesion.
- Suitable as a non-removable varnish to protect the painting and give it an evenly glossy surface.
- Translucent when wet, transparent after drying (crystal clear).

Glazing medium

Gloss medium & varnish

Application

- As a thinner: mix with thin paint mix to increase the volume and transparency while retaining the viscosity of the paint. Mix with thick paint in order to increase the volume and transparency and to reduce its viscosity.
- As a fixative: to increase the brilliance or glow of your work (acrylic paint, pastel, graphite or crayon).
- Mix one part gloss medium & varnish with one part distilled water. Apply with an atomiser or airbrush.
- As a ground: use instead of gesso as a transparent ground for acrylic paint. This makes the substrate visible. Wash cotton or linen canvas first to prevent discoloration.
- With pigment powder: use as a binder with powdered pigment as an economical way of making thin, student-quality paint glossy.
- As a glue: suitable for collages with newspaper and light materials.

Matt medium

Here mixed with:
raw sienna
cadmium orange

Matt medium is a classic medium used to render paint more pliable for delicate brushwork, or as a glue with a matt sheen for collages. It has a creamy consistency and is extremely effective with opaque colours. Mix with gloss medium & varnish for a silky gloss result.

Properties

- Creates a matt or toned-down, non-reflective effect when added to acrylic paint.
- Mixable with any acrylic paint to increase its transparency and colour; make the paint more matt; improve the integrity of the paint layer; facilitate its flow; make the paint film more flexible; and improve adhesion.
- Can be mixed with gloss medium & varnish for a semi-glossy or satin-sheen medium.
- Opaque in a wet state, translucent when dry.

Application

- **As a thinner:**
- Mix with thin paint to increase the volume and transparency while retaining the viscosity of the paint.
- Mix with thick paint in order to increase the volume and transparency and to reduce the viscosity.
- **As a fixative:**
- Suitable as a fixative to increase the brilliance or depth of your work (acrylic paint, pastel, graphite or crayon). Mix one part gloss medium & varnish with one part distilled water. Apply with an atomiser, fixative sprayer or airbrush.
- **As a ground:**
- Recommended liquid medium as a transparent ground for acrylic paint with excellent grain and adhesion. This ensures that the colour and texture of the ground remain visible. Suitable as a replacement for hide glue, which is traditionally used as sizing for oil painting.
- Wash the canvas before use to prevent substrate-induced discoloration, or SID. If you are using acrylic medium as a size on cotton, linen or hardboard, the medium may extract substances from the carrying substrate when drying. This results in SID, and unpainted areas may discolour.
- External murals: if the ground or wall is fairly smooth, a single layer of medium can be painted on with a brush before applying the gesso, or two layers can be applied with an aerosol.
- **As a size:**
- Can be used for collages with newspaper and light materials.

In a wet state

Dry

Slow-dry blending medium

Here mixed with:
quinacridone magenta
ultramarine blue (red shade)

A blending medium that delays drying time is essential when creating soft edges and moulded shapes. It is used to increase the 'pot life' (the time that paint remains workable) of acrylic paint by more than 40 per cent, making it easier to mix colours. This medium contains a binder that guarantees the integrity of the paint layer. For this reason you can add it in any quantity, unlike the additive version.

Properties

- A unique formula that extends drying time by a maximum of 40 per cent, allowing better mixing of acrylic paint on the ground.
- Increases the flow of thick paint and resembles thin paint in its consistency.
- Blends with paint in any desired quantity to increase the colour depth, transparency, brilliance and flow; makes the paint layer more flexible; and improves adhesion.
- Dries clear and displays a full, rich colour when dry.

- Can be added in any desired quantity to paint, without affecting the strength of the paint layer, unlike retardant additives.
- Translucent when wet, transparent after drying.
- Flexible and waterproof when dry, will not yellow.

Application

- Formula developed for techniques where slower drying is required. May also be used as a glazing medium in various conventional techniques, such as airbrushing, brushwork, glazing, collage and murals.
- **As a thinner:**
- Mix with thin paint to lengthen the drying time and to increase volume and transparency while retaining the viscosity and fluidity of the paint.
- Mix with thick paint to slow the drying time, and to increase volume and transparency while thinning the paint at the same time.
- **As a fixative:**
- Use as a fixative to increase the brilliance or depth of your work (acrylic paint, pastel, graphite or crayon). Thanks to the extended drying time, the media can be worked before finally fixing on the ground. Use an atomiser or airbrush filled with a mixture of one part medium and one part water.

Ultra matt medium

Here mixed with:
naphthol red
raw sienna
cadmium orange

An extremely matt, fluid medium. It maintains the opacity of the paint and thins the paint to double its volume without altering the character of the colour. Ideal for large projects where no transparency is required. Dries completely matt without any degree of gloss or brilliance.

Properties

- Increases the volume of paint while maintaining the opacity of the paint it is mixed with.
- An economical way of increasing the volume of thin paint with little or no visible loss of colour intensity and opacity or alteration of tone.
- The opacity of paint mixed with ultra matt medium is greater than that of paint that has been thinned with another medium to the same degree, with the exception of modelling paste.
- The degree to which paint can be thinned down depends on the various pigments.
- If you add more than 50 per cent ultra matt medium, it can have the same effect as a weak white, which takes the value of the paint up by about one level. This is more evident with darker colours than with light colours.
- Paint mixed with ultra matt medium will dry with a matt sheen.

Application

- **Gouache:**
 - Mix with opaque thin paint for a matt sheen and the appearance of gouache (opaque watercolour or poster paint).
 - This gouache-type paint is waterproof, flexible, lightfast and permanent when dry. Traditional gouache paint does not have such properties; it remains very sensitive to humidity and needs to be properly protected when dry.
- **Murals:**
 - Mix with thin paint for effective doubling of the volume for underpainting on murals. For top layers, use colours with Class I lightfastness without ultra matt medium.
- **If the paint runs out during painting:**
 - Use as a thin paint mixing colour if paint runs out during painting. If you are halfway through a specific area, decide whether you have enough paint to finish that section. If not, then add an equal quantity of ultra matt medium. The colour and opacity will remain the same, but the volume will be doubled. You can finish that section without having to mix new paint.
- **Underpainting:**
 - Mix with thin paint during the first underpainting to double the quantity of paint. Thin paint covers three times as much area as thick paint.

In a wet state

Dry

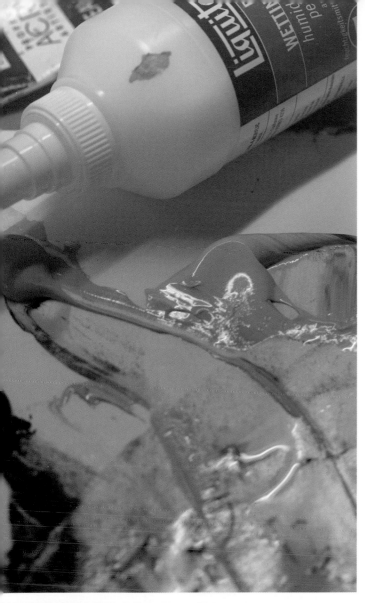

Palette wetting spray

Here mixed with:
phthalocyanine blue (green shade)
phthalocyanine blue (red shade)
cadmium red medium
quinacridone magenta
raw sienna

Palette moisturiser or wetting spray, which delays the drying of the paint. Spray this innovative fluid acrylic resin on to your palette or directly on to a painting. This medium makes mixing paint easier, can be used on thin layers of paint, and maintains the structure of the paint. Regular use will prevent skin from forming on the paint.

Properties
- An innovative fluid acrylic resin to delay drying of acrylic paint.
- Makes it possible to keep paint fresher on your palette for longer and prevent skin formation.
- Improves colour mixing on the substrate.
- May be used to thin paint while keeping the integrity of the paint layer intact.

Application
- Repeated use to keep the palette moist.

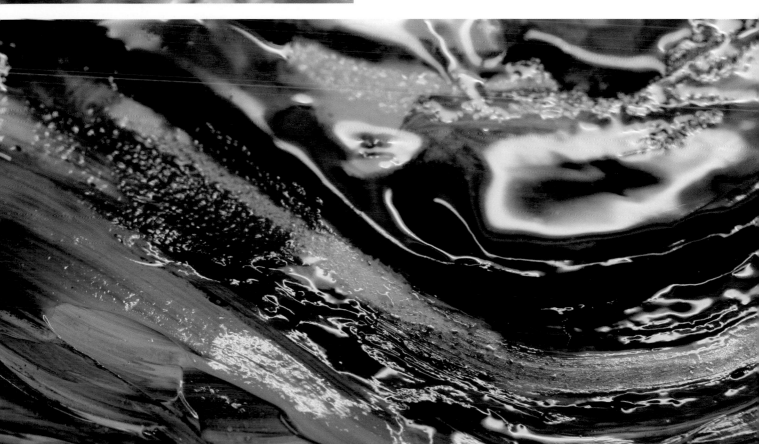

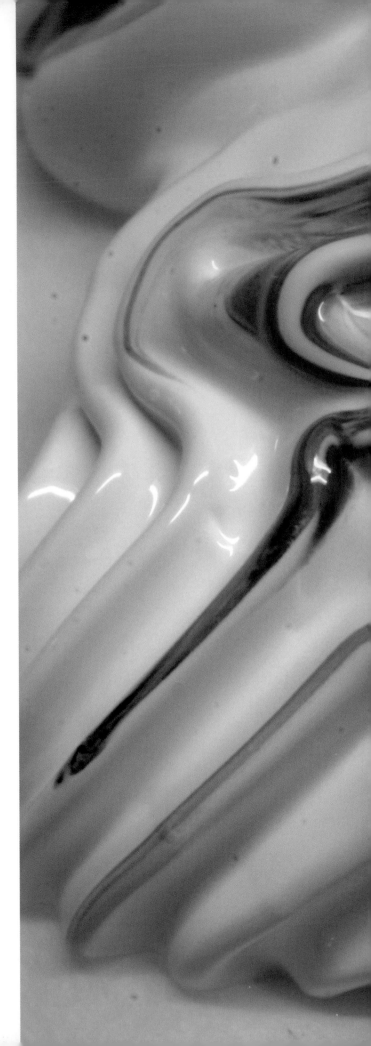

GEL MEDIA

Gel media are the counterpart of liquid media; they are at the opposite end of the spectrum. They give more body to thinner paints for impasto working, increase paint volume and render paint more transparent. Gels also ensure longer 'pot life' because they delay the drying of thinner paint layers. These media also modify acrylic paint in all kinds of ways, and because they contain acrylic resin they also contribute to adhesion and permanence.

Gel mediums

- Provide more body.
- Increase pot life.
- Dry transparently or translucently.
- Increase the volume of paint.
- Hold brush or knife strokes firmly.
- Provide an excellent permanent size for collages.

General characteristics

- Media with a lot of body, intended to retain three-dimensional shapes; to make thick layers; to increase paint volume and drying time; and to obtain various degrees of transparency and gloss.
- Mix with thin paint to increase paint viscosity.
- Mix with thick paint to retain or increase paint viscosity.
- For paint layers with various viscosities and diverse gloss and visual effects.
- Media appear milky when wet, but dry transparently or semi-transparently (unless stated otherwise). A wet medium/paint mix is lighter in colour than the same dry medium/paint mix.
- The thicker it is applied, the more opaque the final paint layer.
- All gels can be used as binders for pigment powder and auxiliary materials such as sand, sawdust, etc. Too much texturing material in media can result in brittleness.
- All gels are excellent glues for fixing heavy objects in a ground.
- Mix gels with acrylic paint to increase pot life.

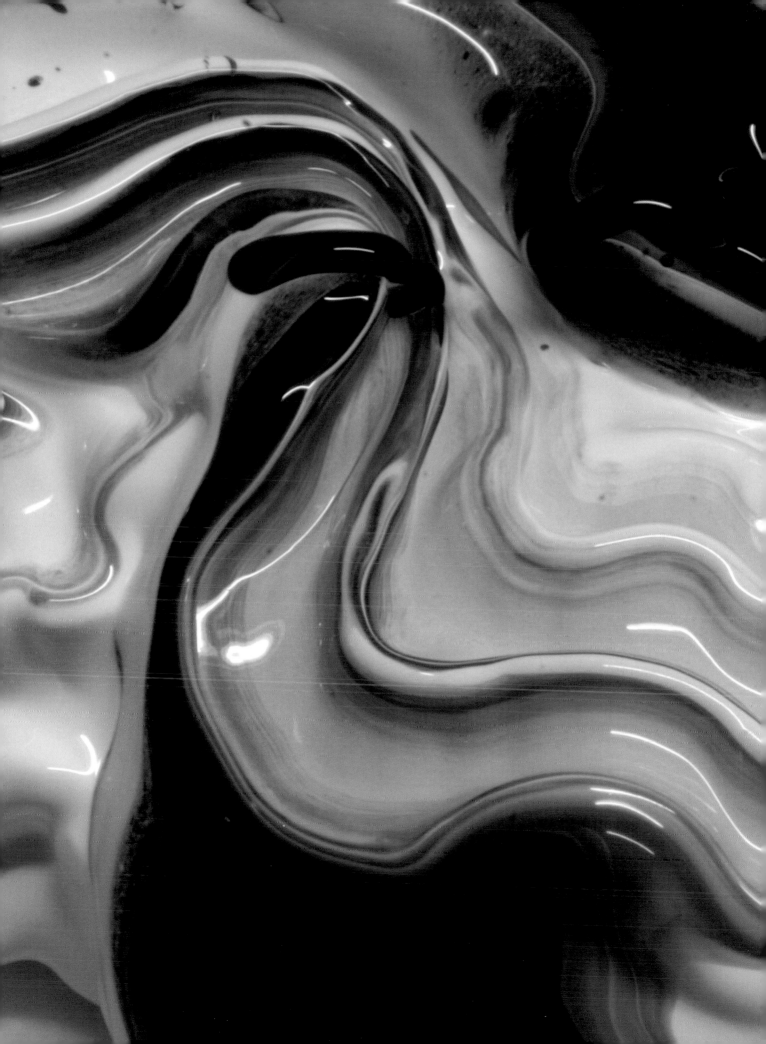

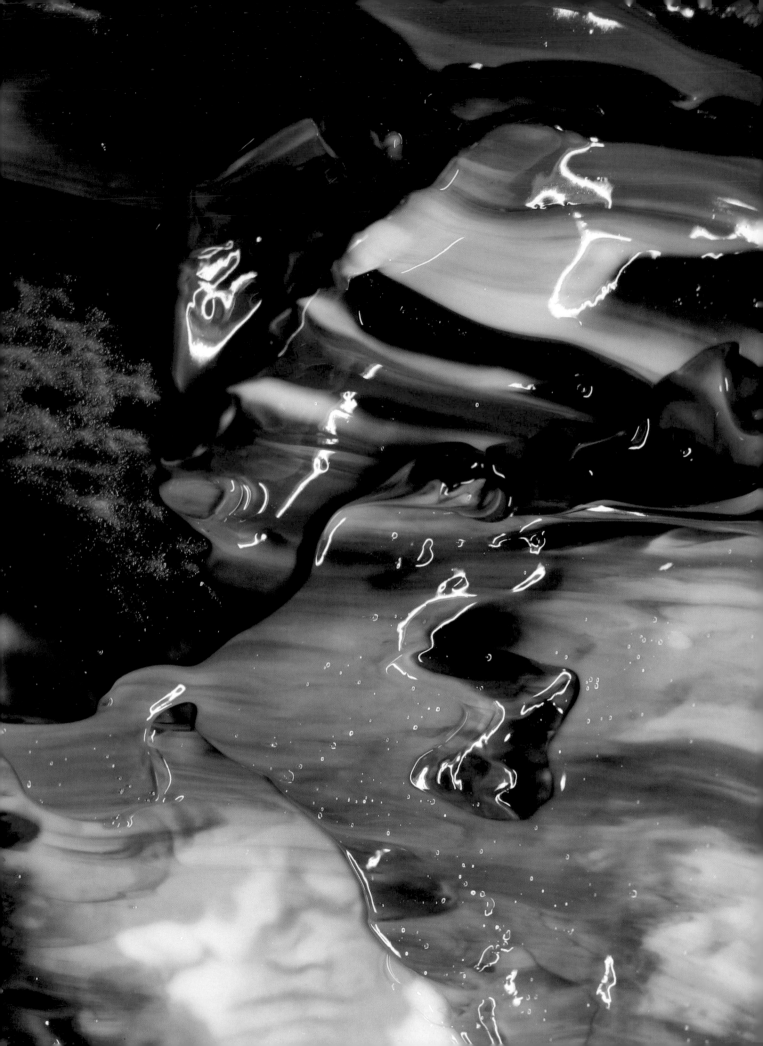

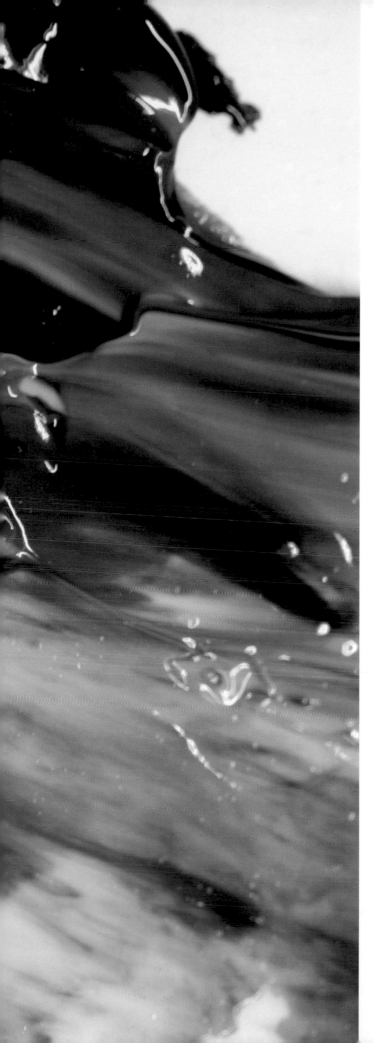

Gloss gel medium

Here mixed with:
phthalocyanine blue (green shade)

Gloss gel, excellent for retaining brushstrokes. It increases drying time and offers paint more body. Mix with transparent colours for impasto glazes with a lot of depth and brilliance. Excellent for transfers of printed work.

Properties
- Glossy when dry.
- Viscosity and body are similar to thick paint.
- Translucent in a wet state, (semi-)transparent when dry. Thicker layers are less transparent when dry.
- Ideal medium for mixing with thick paint to increase gloss and transparency of the paint without modifying its viscosity.
- Mix with thick paint to obtain a paint that is equal to oil paint in terms of colour depth.

Application
- **As a thinner:**
 - Mix with thin paint to increase the volume and transparency but retain the viscosity of the paint.
 - Mix with thick paint to increase the volume, transparency and viscosity.
- **As a ground:**
 - Use as a transparent ground for acrylic paint instead of gesso. The ground remains visible. Wash cotton or linen canvas before use to prevent discoloration. Apply gloss gel medium to the canvas with sufficient pressure to force the medium into the fabric or canvas and ensure good bonding between the gel and canvas.
- **Pigment powder:**
 - Use as a binding medium for pigment in powder form to create effective student-quality gloss paint. Pigments must be suitable for use with acrylic emulsion.

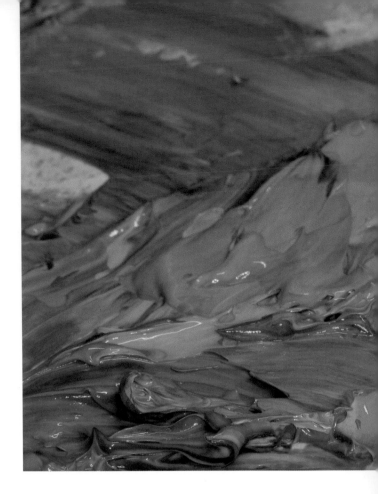

Gloss heavy gel medium
Here mixed with:
viridian hue

This glossy, very thick gel medium increases pot life and reinforces brilliance and transparency. Mix with acrylic paint to increase the volume and obtain an oil paint-like consistency which retains brushstrokes and knife marks.

Properties
Very heavy medium with high density that dries to a translucent and glossy finish.
Mix with acrylic paint to give it more volume, density and viscosity (the consistency of oil paint), and so that it retains brush or palette knife marks.
Thins paint while retaining brilliance and transparency.
Makes paint workable for longer than other gel media.

Application
- **As a thinner:**
 - Mix with thin and thick paint to increase volume and transparency as well as viscosity.
- **As a ground:**
 - Read 'Gloss gel medium' (Application) for more information.

- **With powder pigment:**
 - Use as binder for pigment in powdered form to create a cheap, extra-heavy, thick, student-quality glossy paint. Pigments must be mixable with acrylic emulsion.

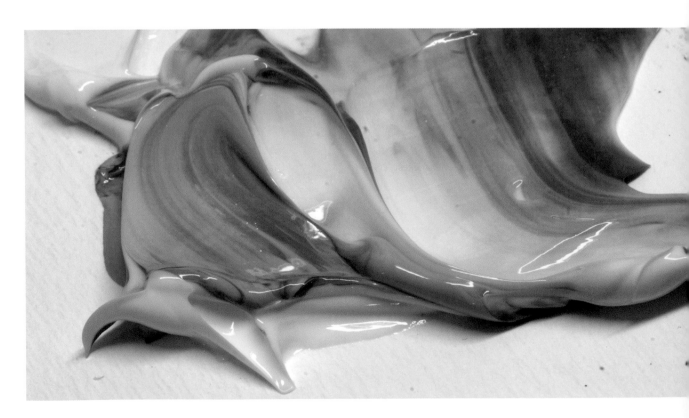

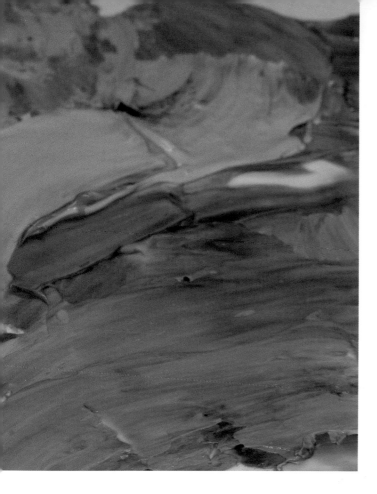

Gloss super heavy gel medium

Here mixed with:
cobalt blue hue

This glossy, ultra-heavy gel offers additional resistance, thus giving paint a more rigid and oil paint-like feel. Ideal for creating high reliefs and for applying paint in a sculptural style. Ensures that paint retains its shape after drying with minimal shrinking. This medium remains workable for longer than most other gel media.

Properties

- Extremely thick, ultra-heavy. The thickest 'crystal clear' gel.
- A lot of body, very dense, with great resistance for a stiff, oil paint-like feel.
- Dries clear to translucent, depending on layer thickness.
- Very little shrinkage during drying.
- Excellent sizing for collages and mixed techniques.
- Thins paint, and increases brilliance and transparency.
- This medium remains workable for longer than most other gel media.
- Flexible and waterproof on drying, will not yellow.

Application

- **As a thick thinner (extender) for thick paint:** Mix with thin and thick paint to increase paint viscosity, body, transparency and colour clarity, and to increase volume.
- **As a ground:**
- When applying to a ground with high relief, press sufficiently to work the gel into the unprepared canvas and guarantee good adhesion. Paint over the gel when it is dry.
- **Collage:**
- An excellent size for collage and collage techniques.
- **With powder pigment and other additives:**
- Be careful not to add so many foreign materials that you compromise the strength of the paint layer. Only use substances that are compatible with acrylic emulsion.
- Use as a binding medium for pigment in powder form to create economical extra-heavy (thick) student-quality glossy paint. Pigments must be mixable with acrylic emulsion.

In a wet state

Matt gel medium
Here mixed with:
burnt sienna opaque

A thick gel which gives a translucent matt effect after drying. Ideal for collages with heavier objects. Can be combined with gloss gel to create a specific satin sheen.

Properties
- The same features as gloss gel medium, except that it dries to a silk matt finish.
- Viscosity and stiffness are similar to that of thick paint.
- Matt gel medium adheres better than gloss gel medium and gloss heavy gel medium.

Application
- **As a thinner:**
- Mix with thin paint to increase volume and transparency, while retaining the viscosity of the paint.
- Mix with thick paint in order to increase the volume, transparency and viscosity of the paint.
- **As a ground:**
- Recommended thick medium for a transparent ground (size) for acrylic paint, with excellent key and adhesion. Allows the colour and texture of the ground to remain visible to some extent. Can be used as a substitute for hide glue, which is traditionally used for oil paintings.
- Wash cotton or linen canvas before use to prevent substrate-induced discoloration (SID).
- External murals: if the ground or wall is very rough, it is possible to apply a layer of matt gel medium with a brush or palette knife before gesso is applied.
- **For impasto effects:**
- Mix with thick paint to obtain impasto effects that dry with a matt sheen.
- **With powder pigment:**
- Use as a binder for pigment in powder form to create economical thick, matt student-quality paint.

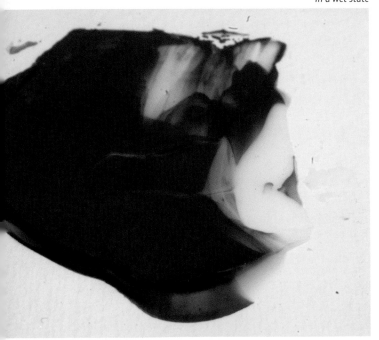

Dry

INCREDIBLE ACRYLICS

Matt super heavy gel medium

Here mixed with:
brilliant yellow green
viridian hue

Matt super heavy gel retains high relief and sharp brush and knife strokes, and either does not shrink or barely shrinks at all. This medium ensures paint remains workable for longer than most other gel media and dries translucent matt.

Properties

- Extremely thick, extra heavy.
- Thick paint with high density and high surface resistance for stiffness that gives the impression of oil paint.
- Dries matt and translucent, depending on layer thickness.
- Very little shrinkage during drying.
- Excellent adhesion for collage and mixed techniques.
- Thins paint.
- This medium ensures that paint remains workable for longer than most other gel media.
- Flexible and waterproof on drying, will not yellow.

Application

- **As a ground:**
- When applying a sculptured ground, exert sufficient pressure to work the gel into the unprepared canvas to ensure good adhesion. Paint over the gel when dry.
- **Collage:**
- Makes an excellent size for collage and decoupage techniques.
- **With foreign materials:**
- Be careful not to add so many foreign materials as to jeopardise the strength of the paint layer. Ensure that the material is suitable for use with acrylic emulsion.

In a wet state

Dry

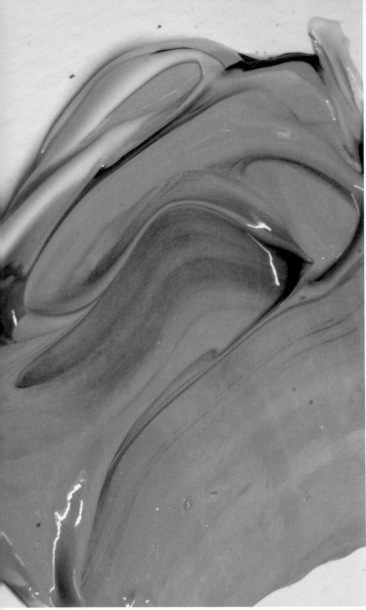

Ultra matt gel medium

Here mixed with:
light blue permanent
cadmium red medium

Ultra matt gel contains a lot of extra resin and dries matt. It maintains the opacity of the paint and extends the paint to double its volume without altering its colour strength. This product is intended for use with opaque colours that must not become transparent. Dries completely matt without any degree of gloss or depth.

Properties
- A translucent white gel of high density and high solid-matter content, which has the advantage of increasing the volume of thick paint without altering the viscosity.
- Add a maximum of 50 per cent of the volume to double the quantity of paint to maintain the colour strength.
- If more than 50 per cent is added, it is similar to a very weak mixing white.
- Maintains the opacity of the paint better than a colourless gel medium.
- Dries semi-matt and gives colours a matt appearance, like gouache or poster paint.

In a wet state

Application
- **If the paint runs out during painting:**
- – Use if a thick mixed colour runs out during painting. If you are halfway through a specific area, decide whether you have enough paint to finish that section. If not, then add an equal quantity of ultra matt gel. The colour and opacity remain the same, but the volume is doubled so that you can finish the section without having to mix new paint.
- **Underpainting:**
- – Blend in with thick paint to double the quantity of paint before the first underpainting.

Dry

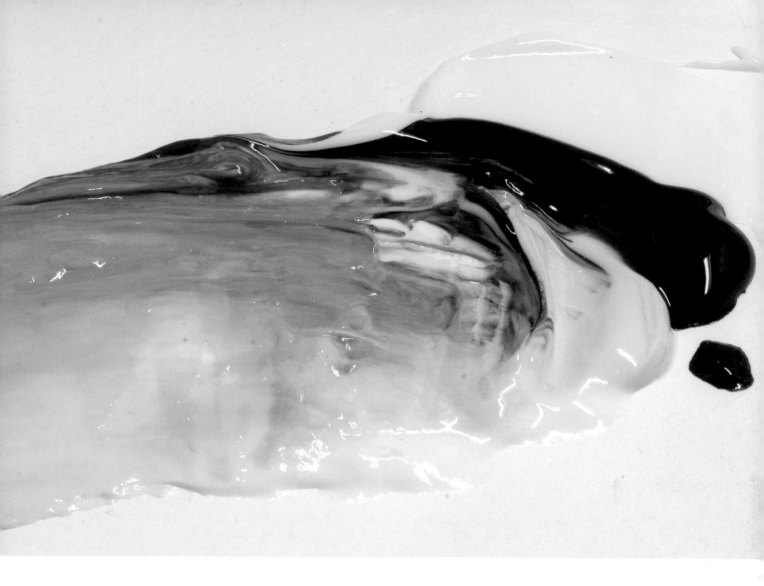

Slow-dry blending gel medium
Here mixed with:
ultramarine blue (green shade)
yellow medium azo

Thick, drying retardant mixture that is used to increase the pot life of acrylic paint by more than 40 per cent in order to be able to mix colours more easily. Can be added at 50 per cent for excellent impasto effects without jeopardising the strength of the paint layer.

Properties
- A unique formula for mixing of acrylic paint on a basic ground.
- Increases drying time by up to 40 per cent for excellent mixing techniques with acrylics.
- As stiff as thick paint.
- Blend with paint in the desired quantity for greater colour depth, transparency and brilliance, and to make the paint layer more flexible and improve adhesion.
- Dries clear and displays the full, rich hue.

- Unlike other retardant additives, this medium can be added in any quantity to the paint without compromising the strength of the paint layer.
- Translucent when wet, transparent when dry.
- Flexible and waterproof on drying, will not yellow.

Application
- This formula has been developed for techniques where slower drying times are desired. Use also instead of a gloss gel medium with all kinds of conventional techniques such as brushwork, thick glazes, collages and murals.
- **As a thinner:**
- Mix with thick paint to extend the drying time and increase volume and transparency while retaining the viscosity of the paint.
- Mix with thin paint to slow the drying time, increase volume and transparency and thicken the paint.

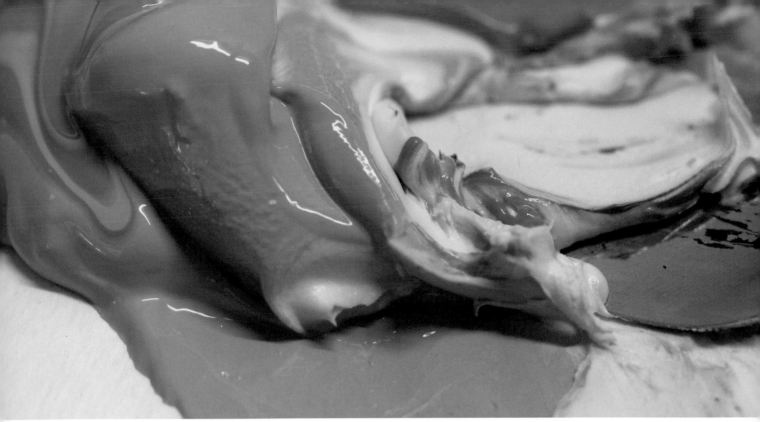

Modelling paste

Here mixed with:
raw sienna opaque
cadmium orange

A very thick, matt and non-transparent paste of marble powder and polymer emulsion that is used to build up heavy textures on rigid grounds. This medium behaves like clay and is as hard as stone when it dries. Can be mixed with acrylic paint or painted over after drying. It forms an excellent ground for acrylic paint, watercolour, graphite or pastel. Marvellous for sculptural applications. Can be sanded after drying and worked with knives or drills. For use on rigid grounds.

Properties

- A malleable paste based on marble powder suspended in 100 per cent polymer emulsion.
- Used to build up heavy textures on rigid grounds and to create three-dimensional shapes.
- Dries as hard as stone. Can be sanded and cut when it is absolutely dry.
- To work it like clay, open the pot and allow the water to evaporate slowly until the product has a consistency like clay.
- Adheres to all non-greasy, absorbent grounds.
- Overly rapid drying can result in superficial, non-structural cracks.
- Works as a very weak mixing white when mixed with acrylic paint, which increases viscosity and stiffness.
- Excellent ground for acrylic paint, crayon, oil bars, watercolour, graphite or pastel.

Instructions

- Apply with a knife, brush, biscuit cutter, dough nozzle, etc.

Dry

- Allow to dry slowly to prevent shrinkage cracks by covering the paste loosely with a piece of plastic sheeting. Apply less than 6mm (¼in) thick.
- Mix with acrylic paint for a coloured paste.
- After drying, modelling paste can be painted with acrylics or oil paint.

Application
- **Sculptural:**
- Apply in thin layers and allow every layer to dry before applying the next one.
- Allow any cracks to dry and fill with another layer of modelling paste.
- **Rigid ground:**
- Use directly out of the pot.
- **Flexible ground:**
- Mix modelling paste in equal parts with gloss gel medium, matt gel medium or gloss heavy gel medium.
- **Ground:**
- Apply a thin layer of acrylic modelling paste on a rigid ground (e.g. wood) with a palette knife, painting knife or roller. Allow to dry and sand flat. Repeat if necessary.
- **Absorbent ground:**
- Mix one part modelling paste with three parts gesso.

- Apply with a painting knife or roller. Allow to dry, sand smooth. Repeat if necessary.
- **Papier-mâché**
- Mix acrylic modelling paste in equal parts with gloss gel medium, matt gel medium or gloss heavy gel medium. Soak the paper in this mixture.

Light modelling paste
Here mixed with:
cadmium orange

Light modelling paste is a mixture of marble powder and polymer emulsion, designed for applications where weight becomes a factor. Can be used to give paint more body and to create pastel tints. Dries as non-translucent matt white and can be mixed with acrylic paint or painted over. A rigid ground is recommended to prevent cracks.

Properties
A lightweight, airy, flexible, viscous and sculptural gel specifically designed for applications that need to be light. Will not make surface cracks. Used separately, it dries to an opaque matt white that will easily absorb colours if necessary.

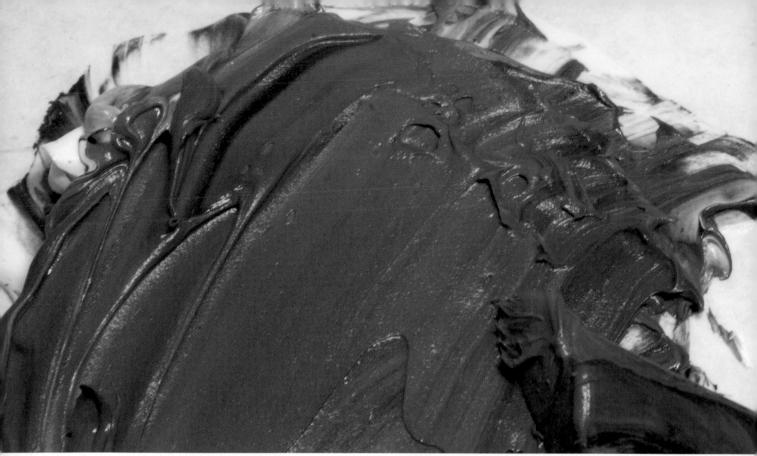

Flexible modelling paste

Here mixed with:
phthalocyanine blue (red shade)
and mixed with:
ultramarine blue (red shade)
quinacridone magenta

A matt, opaque paste made of marble powder and
polymer emulsion. It dries more slowly than other
modelling pastes to a hard but flexible surface.
Especially suitable for building up heavy textures and
three-dimensional shapes. Recommended for use on
grounds which only rarely bend.

Properties

- Extra robust and very opaque.
- A marble paste made from marble powder suspended
 in 100 per cent polymer emulsion.
- Dries more slowly than other modelling pastes to a
 hard but flexible surface.
- Used to build up three-dimensional shapes and
 heavy textures on grounds that must be able to bend
 or move.
- Adheres to all non-greasy, absorbent grounds.
- When mixed with acrylic paint it will behave like
 a weak mixing white that increases viscosity
 and stiffness.
- Excellent ground for acrylic paint, oil paint, wax crayons,
 oil bars, watercolour, pastel, graphite or dry pastel.

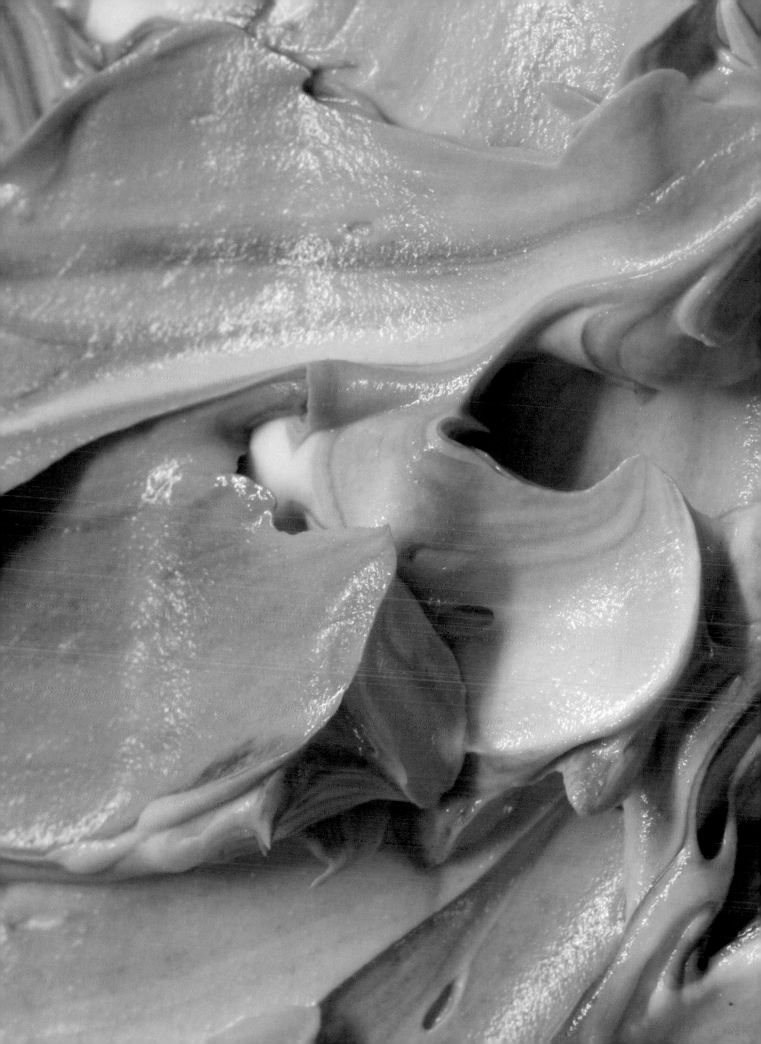

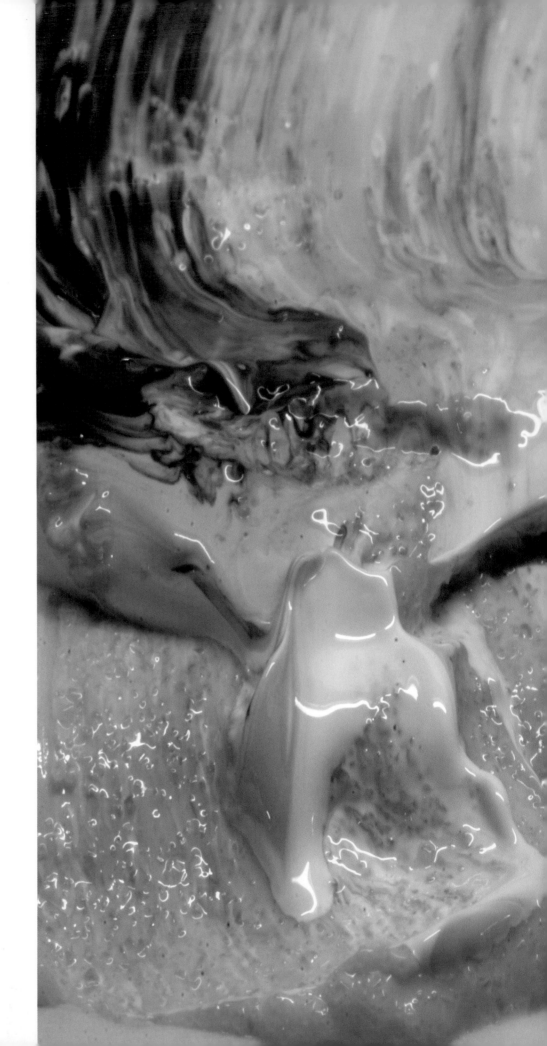

SPECIAL EFFECT MEDIA

There are all kinds of special products, such as liquid media, gel media and texture gels, that have been specifically developed to make various techniques, application methods and special effects possible.

Effects with fluid media

Fabric medium

Applied here on a homemade denim bag.

Textile medium that improves mixing, application and adhesion of acrylic paint if it is used directly on textiles or unprepared canvas. Keeps the paint more flexible after drying.

Properties
- Improves the workability of acrylic paint on textiles.
- Controls the bleeding of colour when thinned down with water.
- Gives liquid paint a flexible and consistent flow.
- Prevents uneven paint layers developing on textiles with a coarse texture.
- Reduces the stiffness of dried acrylic paint on fabric.
- Reduces the need to roughen the texture of the fabric with an abrasive to ensure that the paint adheres to or penetrates the surface.

Application
- Mix medium with acrylic paint to make wet-on-wet mixing easier.
- Medium can be added directly to textiles in order to mix colours.
- Watercolour on fabric.
- Use fabric medium in an approximate ratio of five to one with thin paint to control bleeding of colours.

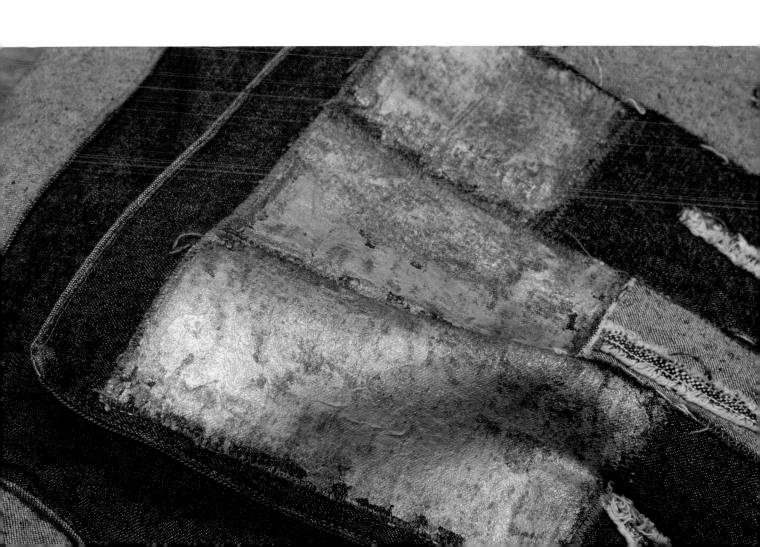

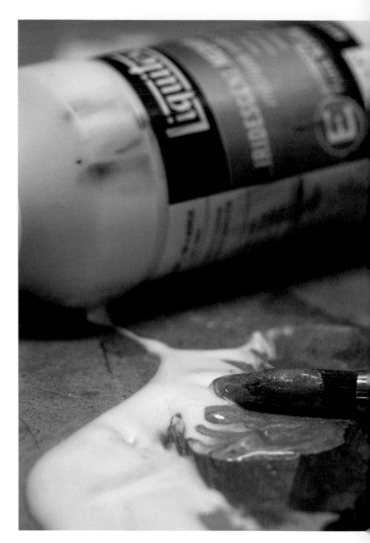

Iridescent medium

Here mixed with:
quinacridone crimson

Iridescent medium makes acrylic paint richer and fuller with a metallic or mother-of-pearl effect. Dries translucently and will not oxidise. Even the smallest addition can make a painting glitter or sparkle. Gives the most dramatic effects when mixed with transparent colours. Try this also on other dry paint for unique effects.

Properties
• Generates a series of iridescent or metallic colours when mixed with acrylic paint.

• Opaque in the wet state, transparent after drying.
• Will not oxidise.

Instructions
• Mix with small quantities of paint and gradually add more paint until you have achieved the desired iridescent effect and the transparency aimed for.
• Transparent colours work best, but you can also use opaque colours.
• Colour becomes more transparent the higher the percentage of medium.
• Colours become more iridescent after drying and will reflect and glitter a lot more.
• Use directly from the pot for mother-of-pearl-type colours.

Airbrush medium

Here mixed with:
burnt sienna
quinacridone crimson

A pre-filtered, ready-to-use medium for easy thinning of all acrylics, watercolours and gouache paints, so they are the right viscosity for the airbrush. An excellent choice for coloured washes and watercolour techniques in acrylic paint. Easy to mix with different media to modify viscosity and working characteristics. Even when highly thinned, the paint layer maintains its integrity, while the medium prevents accumulation of paint and blocking of the airbrush. Combine with thin paints for the best results.

Properties
- Pre-filtered and pre-reduced for the correct consistency for airbrush techniques.
- Easily thins down acrylic paint to a sprayable viscosity.
- Prevents blockage of the airbrush and accumulation of paint around the spray nozzle while spraying.
- Makes it possible to spray efficiently with acrylic paint and retain the character of the paint layer.

Instructions
- Mix airbrush medium with thin paint. Sieving is not necessary.
- Mix airbrush medium with thick paint. Sieve the mixture to remove particles of undissolved pigment.
- Start with 50 per cent airbrush medium to the quantity of paint. Mix thoroughly.
- If necessary add more airbrush medium for a good flow through the airbrush. The proportion of airbrush medium to paint can vary per colour because of the variation in the size and concentration of the pigment.
- The size of the nozzle on the airbrush and the spray pressure (PSI) will determine the airbrush medium/ paint mixture. The larger the nozzle, the greater the possible percentage of paint.
- Keep the airbrush wet as long as you are working with it. Never allow paint to dry up in the airbrush.
- Clean the airbrush with water, a mixture of water and ammonia, airbrush cleaner or alcohol.

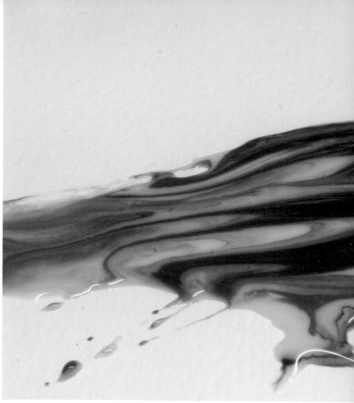

In a wet state

For marbling

Dry and rolled up

Picking off

Pouring medium

Here mixed with:
naphthol redlight

Mixed for marbling with:
naphthol red light
yellow medium azo

This pouring medium was specially developed for pouring techniques without cracks, for example to make moulds and sheets of acrylic. Can be mixed with any acrylic paint to create flexible, even-coloured paint layers.

Properties
- Produces even moulded shapes, poured sheets and fluid paint layers.
- Will not crack or tear and will not retain any bubbles in the drying paint layer.
- Retains strong glossy and wet appearance when dry.
- Flexible and waterproof on drying, will not yellow.

Application
- Mix with thin paint to ensure that this dries into a flexible and evenly coloured paint layer.
- Coordinate marbling and thinning with the required effect.

SPECIAL EFFECT GEL MEDIA

String gel

Here mixed with:
phthalocyanine blue (green shade)
cadmium yellow light

String gel has a honey-like viscosity and can be mixed with thin and thick paint to create all kinds of effects. Paint mixed with this gel will drip like string in a thin, continuous stream from the point of the brush or knife. This application method offers maximum control over dripping or poured paint, making it possible to apply more details than via other means. In traditional applications with a brush, the paint 'hangs' on the brush so that long, dragging effects can be created. The transparency and extent to which it smooths out make this medium even more unique.

Properties
- A gel that levels out by itself with a syrupy, honey-like consistency.
- Strengthens colour depth and increases transparency and flow.
- Dries glossy and transparent.
- After drying it is permanent, flexible and waterproof; will not yellow.

Application
- In abstract painting, where controlled dripping, pouring and splashing offer greater expressive scope.
- This is an illustration of how the unique characteristics of this medium can provide the texture and stylistic impact that help to express the artist's vision.

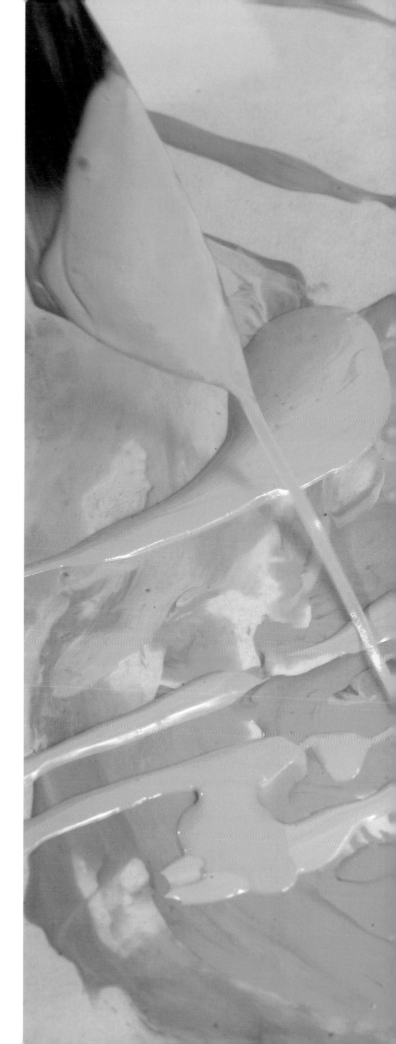

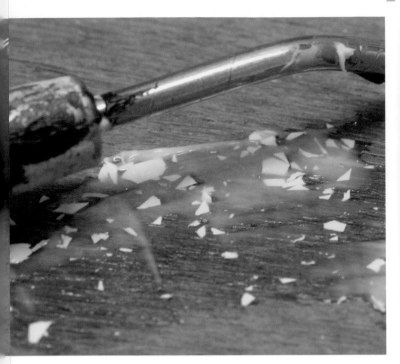

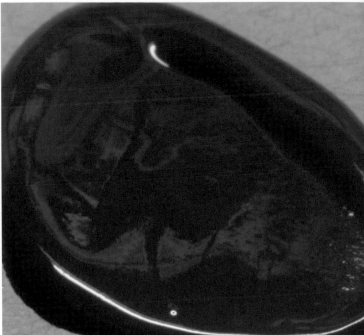

White opaque flakes
Colour used:
cadmium red medium hue

A heavy, coarse gel with white flakes in varying sizes and shapes. The effect resembles snowflakes or coconut flakes.

- A heavy, coarse gel with irregularly shaped flakes of varying sizes.
- White opaque gel is most effective when mixed with transparent or translucent colours or small quantities of opaque paint.
- Can also be used in pure form, even as the top surface.

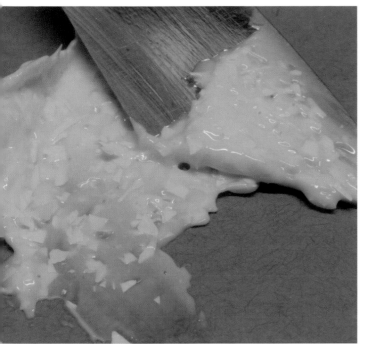

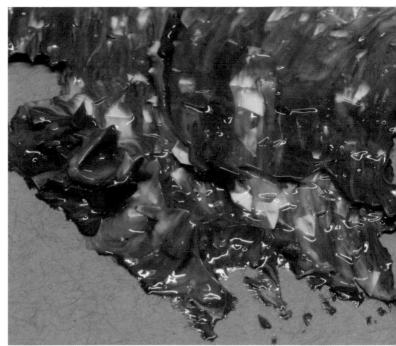

In a wet state

Dry

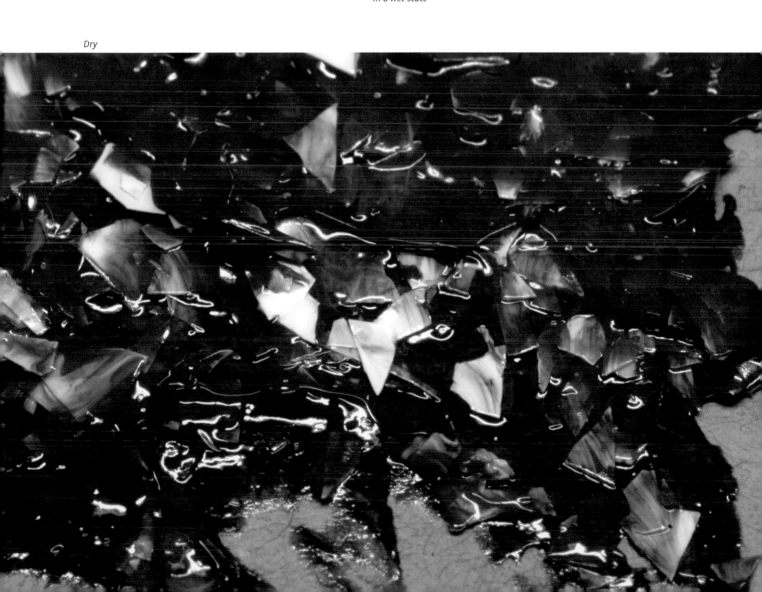

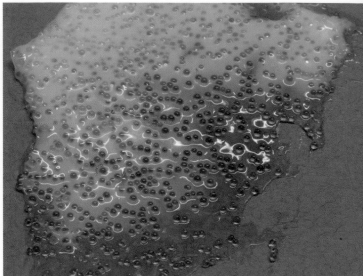

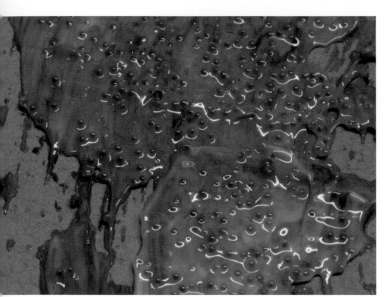

In a wet state

Dry

Glass beads

Colour used:
quinacridone magenta

A medium heavy gel containing clear plastic beads which dries to a semi-shiny surface. Perfect for a texture that resembles soda bubbles.

- A medium heavy gel with clear, spherical additives, which dries to a semi-glossy, reflective ('fizzy') surface.
- Mix with transparent or translucent colours for the most dramatic reflective effects or apply directly from the pot on to dry paint.
- Mix with gloss medium & varnish and small pieces of thin paint for reflective glaze with texture.

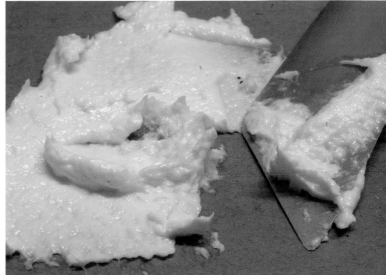

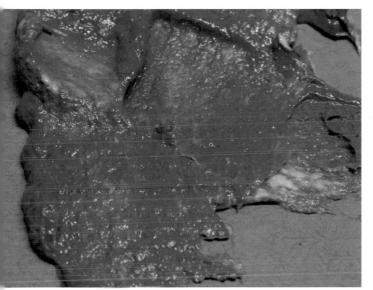

In a wet state

Dry

Blended fibres

Colour used:
cobalt blue

A superb medium for giving painted shapes additional texture and volume. After it dries the thick, non-translucent gel looks like a layer of semi-glossy flexible fibres. It effectively retains high relief and knife strokes when mixed with paint. The result can resemble torn fabric.

- A thick, fibrous gel which resembles a layer of flexible fibres after it dries.
- Add gloss gel medium or gloss heavy gel medium for easier application and to improve adhesion in the wet state.
- Most easily applied with a palette or artist's knife.

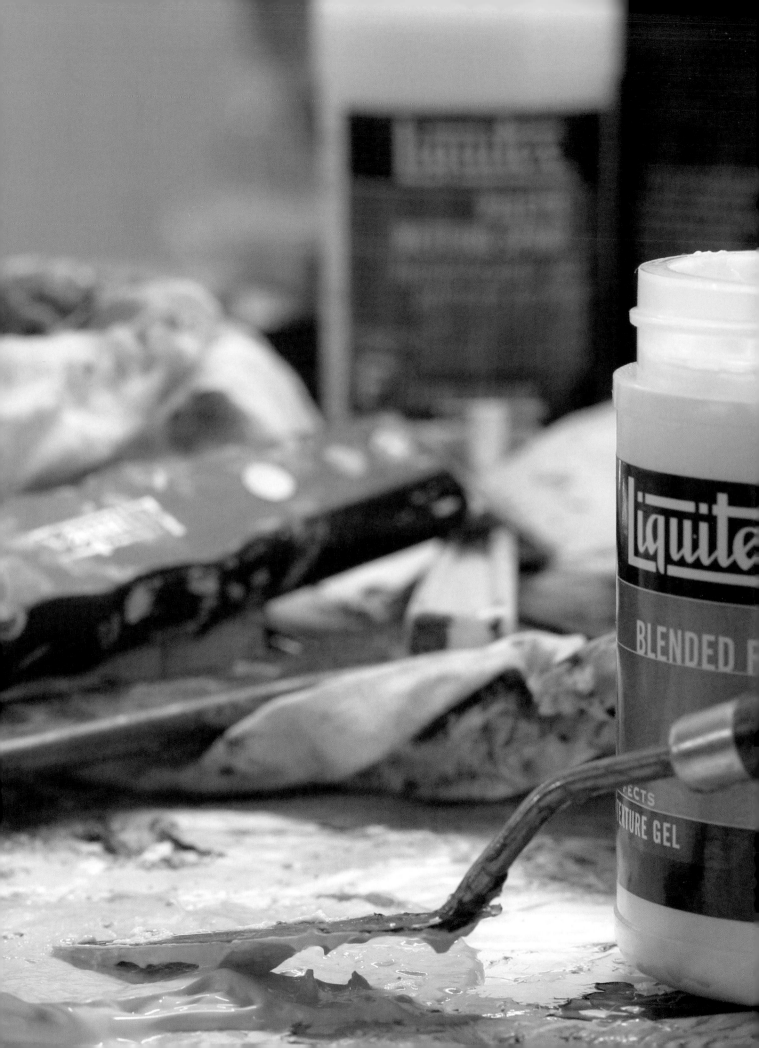

In a wet state

Dry

Resin sand

Colour used:
brilliant yellow green

A thick, coarse gel which dries semi-glossy, with a texture that resembles rough cement. Mix this gel with black lava and ceramic stucco to obtain an absorbent, granite-like surface to which thin paint adheres easily.

- A thick, coarse gel which contains additives of differing sizes.
- Looks like 'raw cement' after drying and also retains its unique texture well when it is mixed with paint.
- Outstanding ground for acrylic paint if you are looking for dramatic effects.

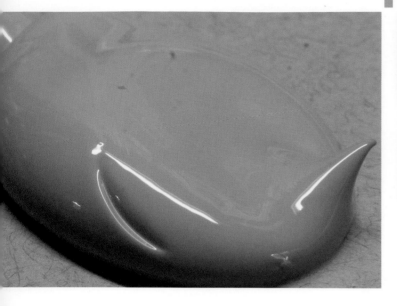

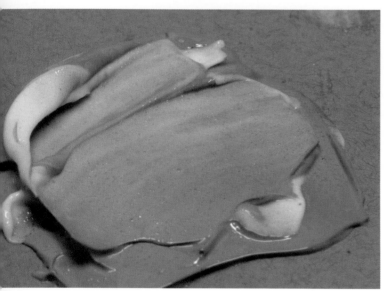

In a wet state

Dry

Natural sand

Colour used:
raw sienna opaque

A gel with a fine structure which dries into something that resembles shiny beach sand. Mix with other types of gel for very specific effects. An excellent choice to give underpainting a bit more 'grain'. Try applying natural sand with a palette knife at an angle to create a pattern of highs and lows.

- A texture gel with a fine structure, which resembles shiny beach sand after drying.
- A very effective ground for acrylic paint, pastel and graphite if work requires fine touches and strokes of blended colours. Easily applied with a brush.
- Most easily applied with a palette or artist's knife.

In a wet state

Dry

Black lava

Colour used:
cadmium yellow light

A glass-clear gel shot through with black specks which add an extra dimension to paint layers. Can be used to darken colours in a painting. Try experimenting with this on dried acrylic paint for added effects.

- A speckled gel containing small, flat, hexagonal dark specks.
- In its wet state it appears to have grey flecks, but after it dries it resembles ground dried black lava rock (because the white binding medium dries clear).
- The black speckling is most effective if mixed with transparent and translucent colours.

ADDITIVES

You can alter the chemical composition (and therefore the working characteristics) of acrylic paint with additives. They can be used to alter, among other things, the flow, coverage or consistency. Because they contain acrylic polymer they can be combined with any product. However, they contain insufficient acrylic resin to be able to act as a binder in the paint mixture. In general it is not advisable to add more than 25 per cent of such additives to paint, nor to add more than one additive at a time.

Additives should be used carefully; don't use more than is needed to achieve the desired effect.

Flow aid

Here mixed with:
cadmium yellow medium hue
quinacridone red orange

An additive that disrupts the surface tension of water. This reinforces the flow, absorption and mixing of water-based paint and ink and minimises brushstrokes. Use flow aid with soft body paint to make thin washed tones without creating hard edges.
Excellent for bleed-through effects on unprepared canvas. Add a maximum of 25 per cent; because the additive doesn't contain any binder, it may affect the stability of the paint layer if you add too much.

Properties

- Use in combination with any acrylic medium or any acrylic paint where improved flow and absorption

and reduced tension and friction in the paint layer are important.

- A flow aid improves the flow, absorption and mixing of every water-soluble paint (such as acrylic paint), ink or colour, and every water-soluble medium.
- Minimises brushstrokes by reducing resistance during application.
- Does not contain any binder. Excessive thinning with flow aid or application on a non-absorbent ground (such as canvas with a gesso ground) may result in poor adhesion. Always do a test piece with your specific technique and ground.
- Will increase flow on non-absorbent ground and standing time (drying time).
- Behaves on absorbent ground like bleed-through colour or watercolour paint.

Instructions

- Flow aid is a concentrate. Thin with water before mixing with paint. Distilled water is preferable because tap water varies in quality.
- Minimum dilution: one part flow aid to ten parts distilled water to make flow aid water.
- Usual dilution: one part flow aid to twenty parts distilled water to make flow aid water.
- Do not use undiluted because this can result in inadequate adhesion, cracks in the paint, permanent stickiness and insufficient water resistance.
- Do not shake or stir quickly, otherwise flow aid will foam. Wait till foam has disappeared before using.
- Absorbent surfaces: use as much flow aid as is necessary. The ground absorbs the flow aid water/ paint mixture.
- Mix flow aid water with water-based paint. Do not mix flow aid with turpentine or oil paint.
- Do not use flow aid for marbling, because with this technique the surface tension of the water must be maintained.

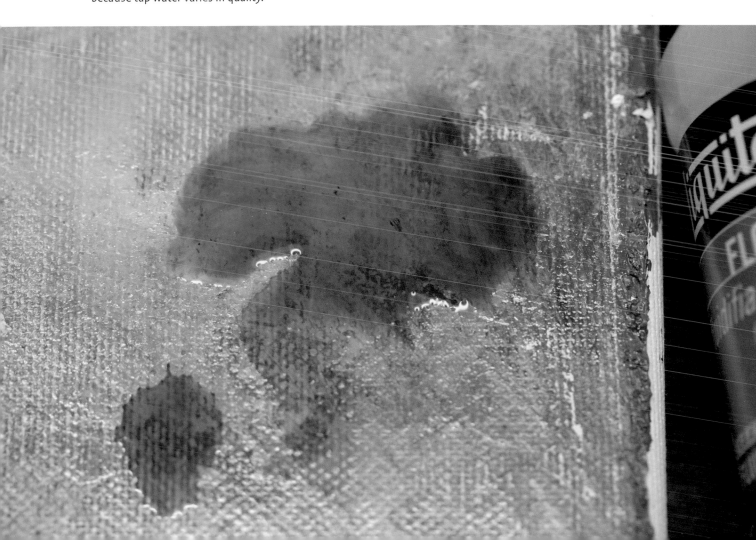

Liquithick

Here mixed with:
cobalt blue

A thickening gel, this is an excellent medium for sculpture effects with a matt finish. When added to acrylic paint and media it makes them as easy to handle as oil paint or wax paints. Works very well with opaque colours because the gel does not increase the transparency and also does not change the colour status. Add a maximum of 25 per cent; because this additive does not contain any binder, it may affect the stability of the paint layer if you add too much.

Properties

- A thickening gel for water-soluble acrylic paint and media.
- Gives characteristics resembling those of oil or wax paint when used in small quantities.
- In higher concentrations it can make the paint or the medium as thick as dough or modelling clay.
- The drying time is twenty-four hours to seven days, depending on the quantity of Liquithick added to the paint or medium.
- Liquithick does not increase transparency.
- Liquithick gives the dried paint layer a matt shine.
- Paint and medium shrink depending on the quantity of Liquithick that is used.

Instructions

- First add a little Liquithick to the paint or medium and mix properly with a palette knife. The correct ratio will depend on the colour and the desired effect.
- Mixing proportions of twenty or twenty-five parts of paint to one part Liquithick will alter the working characteristics.
- Gradually add more Liquithick until you achieve the desired viscosity.
- Do not add more than is necessary for the desired effect and do not exceed a ratio of one part Liquithick to four parts paint, to prevent excessive shrinkage and cracks.

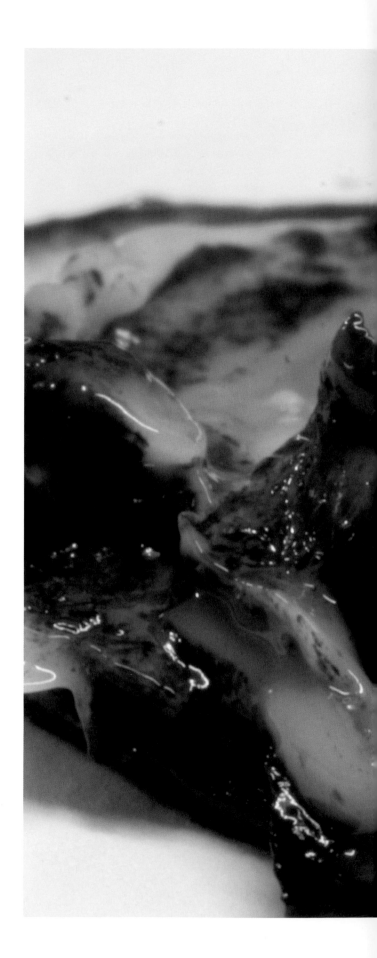

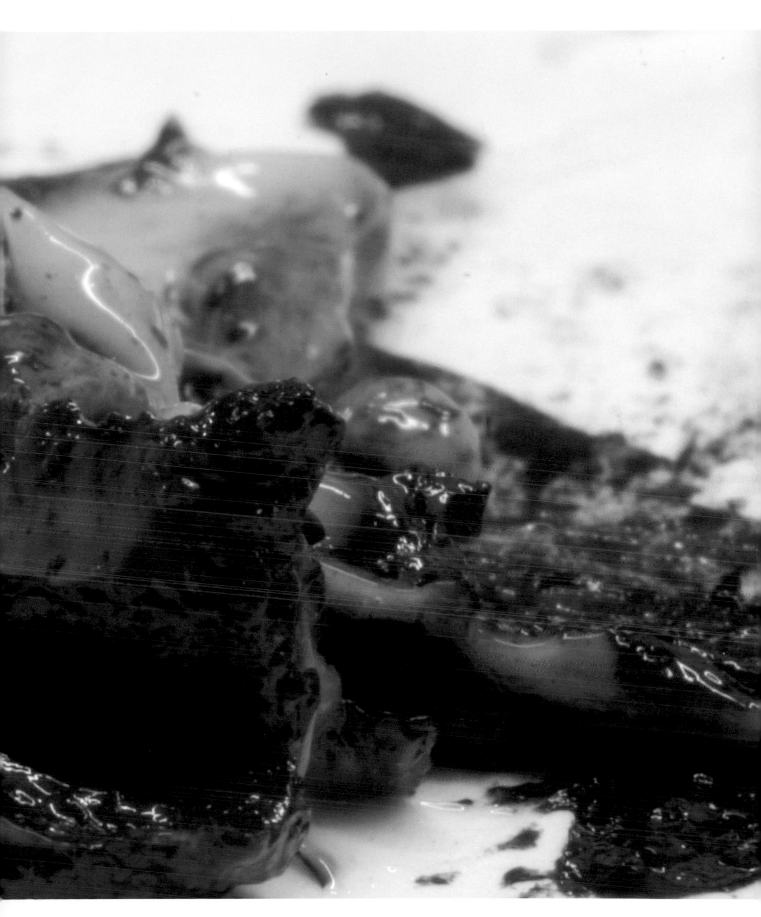

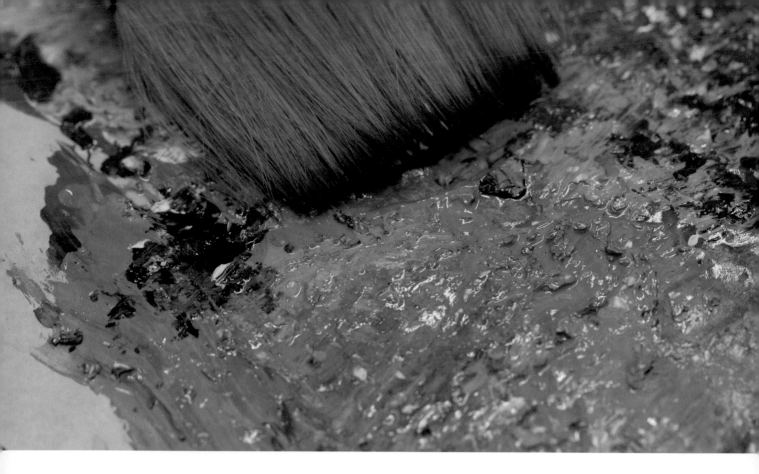

Finishing

VARNISH

There are often doubts about whether an acrylic painting really needs to be varnished. In general it is usually best to varnish your acrylic work, if this is possible. Varnish is applied over dried paint and serves several purposes. The first and most important function is to protect the painting against environmental influences and to protect the pigments against ultraviolet light. Secondly, varnishing can be used to saturate the paint layer and to remove any fogging, so there is a uniform shine over the entire painting. Varnishes are available in various degrees of gloss, all of which can be mixed together. Varnishes are permanent or removable and can be applied on both flexible and rigid grounds.

Advantages of varnishes

Minimise vulnerability to atmospheric pollution and damage to the paint layer. Protect the surface against damage during transportation or exhibiting.
Increase colour clarity and colour saturation.
Give the entire surface an even shine.
Protect colours against ultraviolet light. Every varnish gives some protection, but a varnish with UV retardants protects against discoloration.

Facilitate cleaning, without risk of affecting or damaging the paint layer.

Permanent (not removable)

Properties

- 100 per cent acrylic polymer varnish. Water-soluble as long as it is wet. Chemically stable and waterproof.
- For inside and outside.
- Gives excellent smoothness.
- Translucent when wet, is clear after drying; non-sticky, hard and flexible; does not retain dirt.
- Resists discoloration (does not yellow, and will not white out or bloom) as a result of moisture, heat and ultraviolet light.
- Will allow moisture through depending on the carrying substrate (that is, it breathes).
- Do not use with oil paint.

Different levels of gloss available

- high gloss varnish
- gloss varnish
- satin varnish
- matt varnish

Recommended application method

Choose the desired degree of gloss. Permanent varnish cannot be removed and must always be tested before you apply it to your work. Ensure that the paint layer is totally dry (drying will take seventy-two hours to two weeks, depending on the thickness) before you apply varnish. Only apply varnish in a clean and dust-free environment.

Removable (Soluvar)

- Permanent, removable final varnish based on mineral alcohol for acrylics and oil paint.
- Protects the painting surface and makes it possible to remove dirt from the surface without damaging the underlying paint. When the surface is clean again, it is possible to apply a new layer of Soluvar.
- For inside and outside.
- Goes on smoothly – does not retain any brushstrokes.
- Resists any discoloration (does not yellow, and will not bloom) as a result of moisture, heat and ultraviolet light.
- Glass-like clarity when wet.
- Can be used on both oil and acrylic paintings.
- Remove with mineral alcohol or turpentine.
- Flexible. Will not crack when the surface expands and contracts due to variations in temperature and humidity.
- Contains UV retardants that counter discoloration by dispersing the UV radiation before it can reach the paint layer. The thicker the layer of varnish, the better the protection.
- Do not use when painting on vinyl.

Different levels of gloss available

- Soluvar gloss varnish
- Soluvar gloss varnish aerosol
- Soluvar matt varnish
- Soluvar matt varnish aerosol

Recommended application method

First apply one or two layers of gloss medium & varnish. Allow each layer to dry for one to three hours. Allow the final layer to dry for forty-eight hours. Clean the surface with a lint-free cloth and some white spirit. Apply one to two layers of Soluvar varnish.

Stir Soluvar matt thoroughly before use (do not shake, as this creates bubbles). Now allow each layer to dry for twenty hours. Wait six to twelve months before applying varnish to oil paint.

Only use real white spirit or alcohol (not odour-free) to thin Soluvar if necessary.

Tips for varnishing

- Do not shake varnish, otherwise bubbles may arise that remain visible on the painting.
- It is better to apply one to three thin layers than one thick layer. A thick layer needs more drying time, can become cloudy when it dries and may drip or sag while it is being applied. There is also a greater chance that brushstrokes will remain after drying.
- Lay the work to be varnished flat on a table – do not varnish vertically.
- Bubbles are more likely to form in thinned varnish. Do not rub too hard when applying.
- Apply varnish with long equal strokes. Work from top to bottom and from one side to the other, so the entire surface is covered. Check the varnish layer for bubbles from every angle when applying it, and immediately paint these out.
- Once a section is finished, do not work on it again. If you do this, you run the risk of pulling partly dried varnish into wet paint, as a result of which dark colours may acquire a white haze. If you miss a section, allow the work to dry completely and varnish again.
- Do not apply more than one or two thin layers of matt or satin varnish because thick layers can become blotchy when dry. If you want more than two layers, first varnish with gloss varnish to the desired thickness and only apply matt or satin varnish as the final layer.
- Application with an airbrush is recommended for work with a lot of texture and for vertical works (such as murals).
- Applying varnish with a roller or sponge is not advisable.

Thinning

Thinning helps with penetration and can make it easier to apply varnish. Excessive thinning can result in a weak varnish layer, bad adhesion, spreading, or absorption into the ground.

Removing varnish

- Permanent non-removable varnishes cannot be removed. Do not attempt to remove such varnishes with powerful solvents. Soluvar gloss and matt final picture varnish can be removed.
- Remove varnish in a well-ventilated space.
- Use breathing protection with a double filter (TNO/KEMA-approved) and neoprene gloves. Dampen a soft, lint-free white cloth with alcohol or white spirit (not 'odour-free') or turpentine – nothing stronger. Do not use any ketones or paint cleaners as a solvent.
- Work horizontally. Apply a generous amount of cleaner and leave on the surface for fifteen to thirty minutes. Check regularly. It may take more time, depending on the age of the work and the strength of the cleaner. If the varnish does not dissolve, or dissolves only slowly, use a stronger alcohol or turpentine (cover with plastic to delay evaporation). The label will not tell you whether the cleaner is stronger, but you will notice it from the stronger smell.
- Gently rub an area of 10–25cm² (4–9¾in²) with the piece of cloth until the varnish starts to dissolve.
- Rub the same area again with a clean cloth and clean solvent to remove any residue. Repeat this for the entire area that needs cleaning. If any paint appears on the cloth, stop immediately and allow the paint layer to dry.
- Allow the painting to dry before applying a new layer of Soluvar final picture varnish.

A gloss varnish
Gives the work a more brilliant, contrast-rich appearance than a matt varnish.

4

Applications

Paintings

We have spent some time looking around the artist's 'kitchen'. Now it's time to do some real work!

In this section, I'd like to show you just what you can create with acrylics by using examples of my own existing work. These are paintings that I produced from 2000 to 2008.

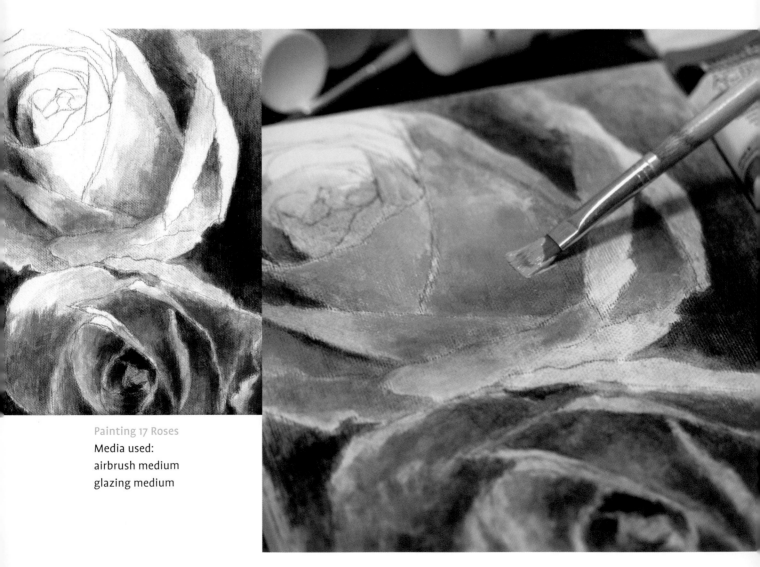

Painting 17 Roses
Media used:
airbrush medium
glazing medium

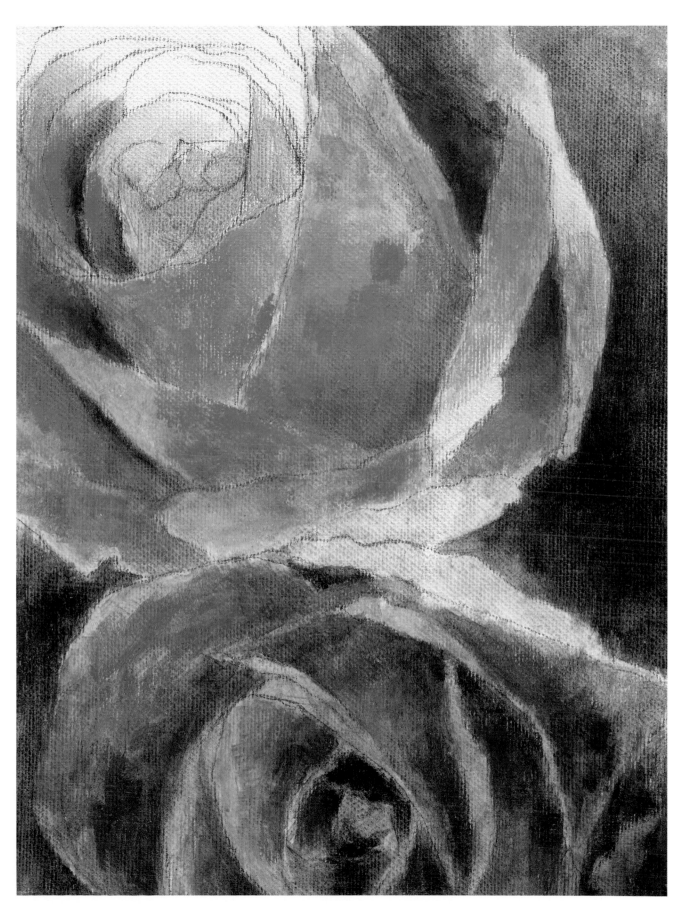

Painting 18 Boat
on Cancale Beach
ceramic stucco

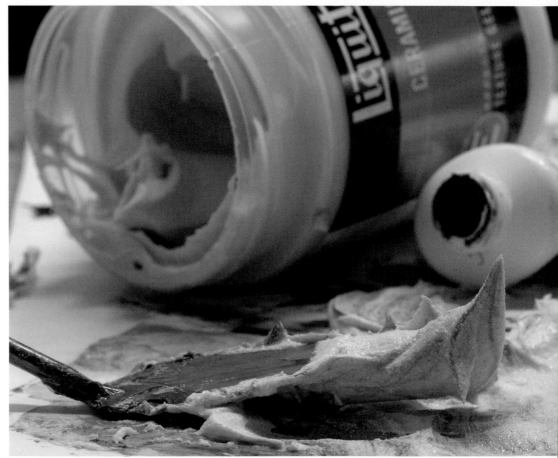

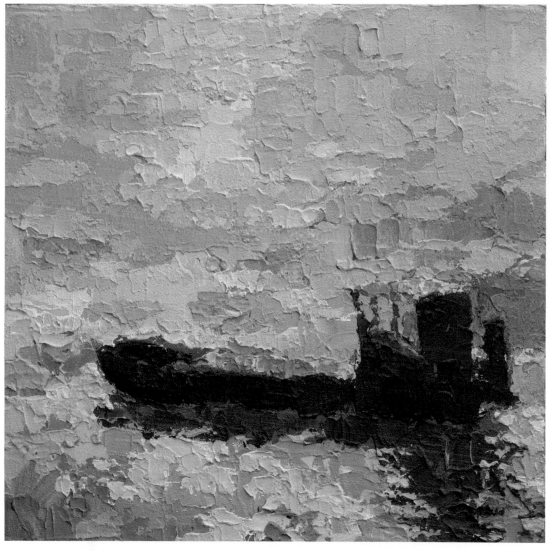

Painting 19
Portrait of Jeroen
modelling paste

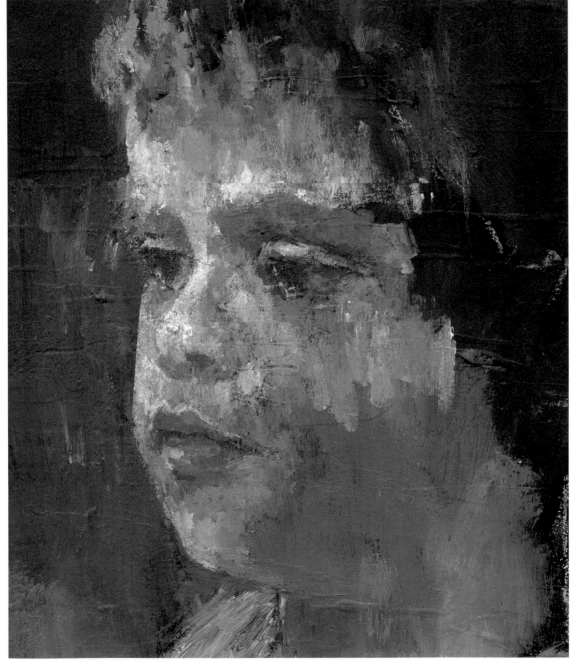

Painting 20
Benoît sur Mer
Liquithick

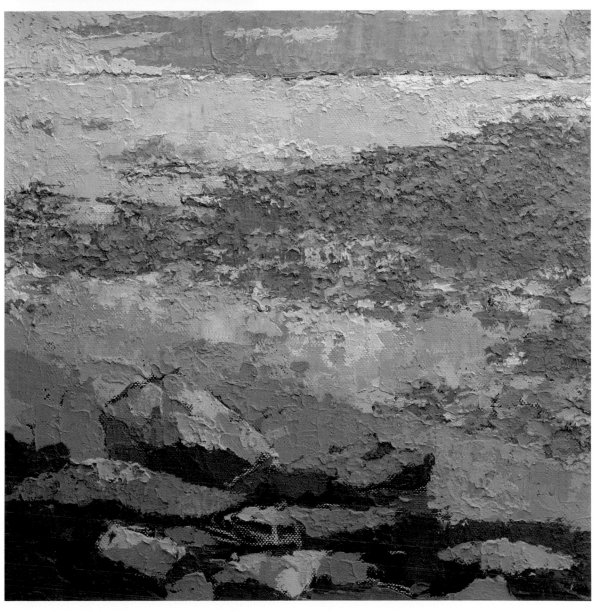

Painting 21 Giraffe
Media used:
iridescent medium
glazing medium

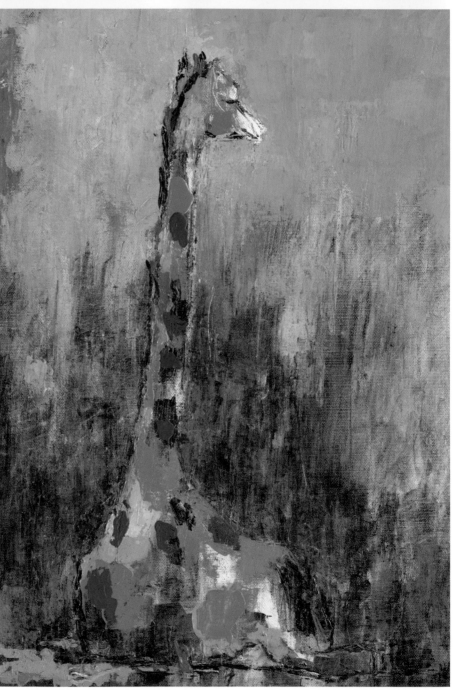

Media used:
ceramic stucco
resin sand

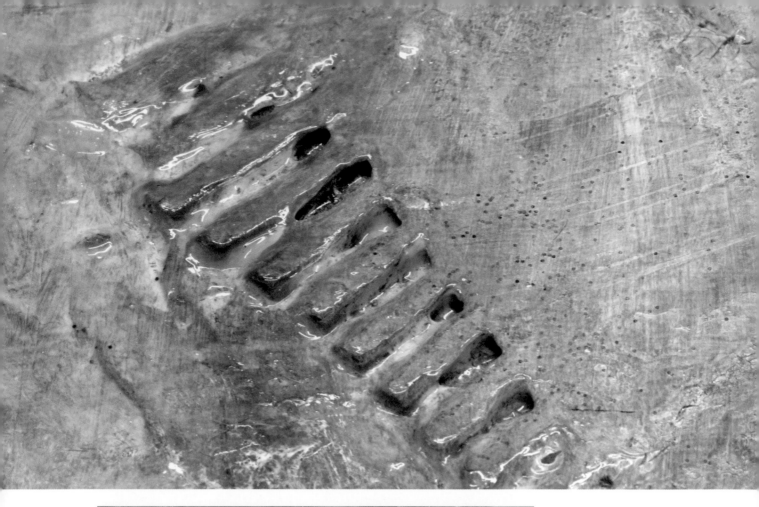

Painting 23 Tutankhamen
Media used:
gloss super heavy gel
black lava
resin sand
iridescent medium

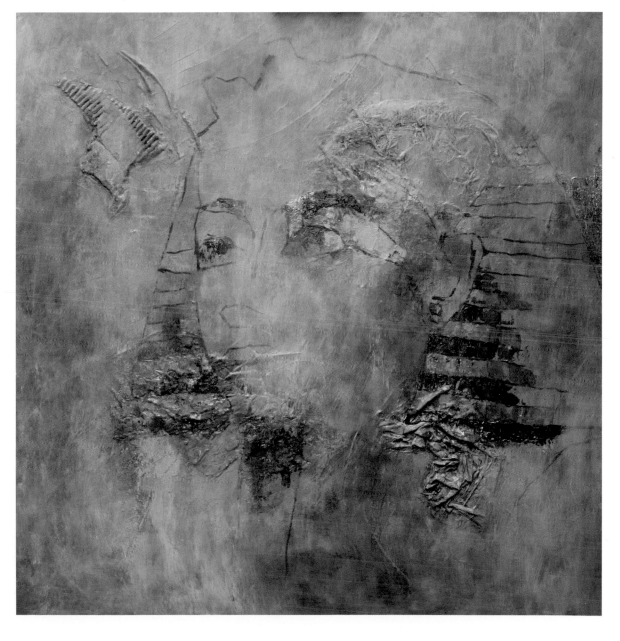

Painting 24 Cancale
Media used:
light modelling paste
resin sand

Media used:
modelling paste
matt gel medium
resin sand

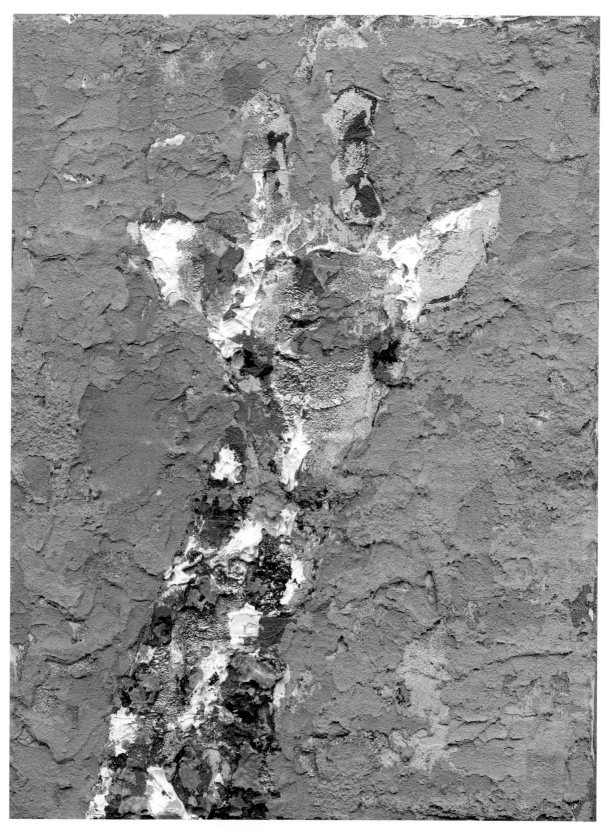

Painting 26 Giraffe 3
Media used:
glazing medium
black lava
iridescent medium

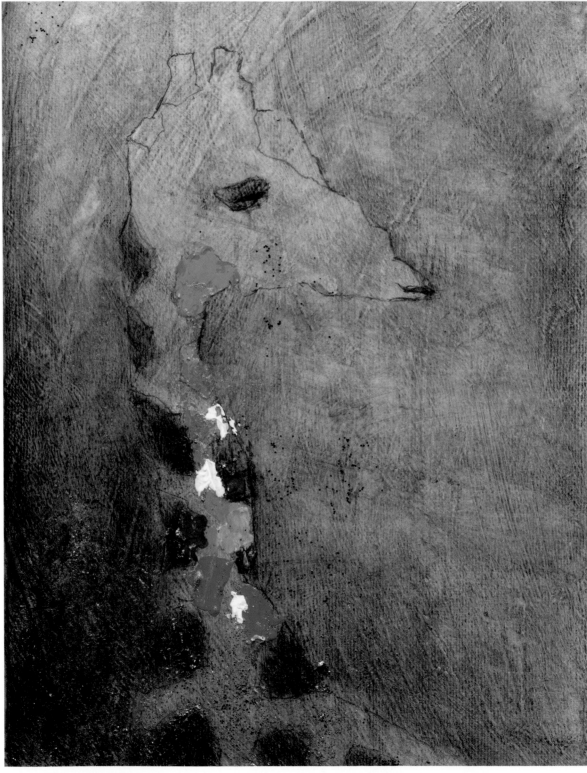

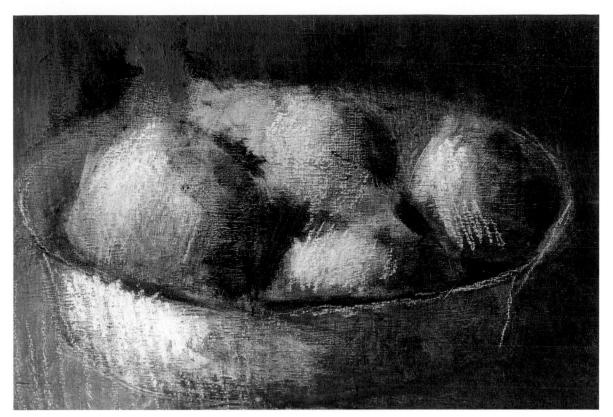

Painting 27 Bowl of Fruit
Pastel on acrylic

Painting 28 Abstract
Acrylics on watercolour with
rice paper

Media used:
gloss super heavy gel
gesso
light modelling paste

Workshops

This section includes a number of works produced specially for this book. Here I give step-by-step instructions for how a painting can be created. In some cases the reference material is also shown, so you can see how it translates into a painting.

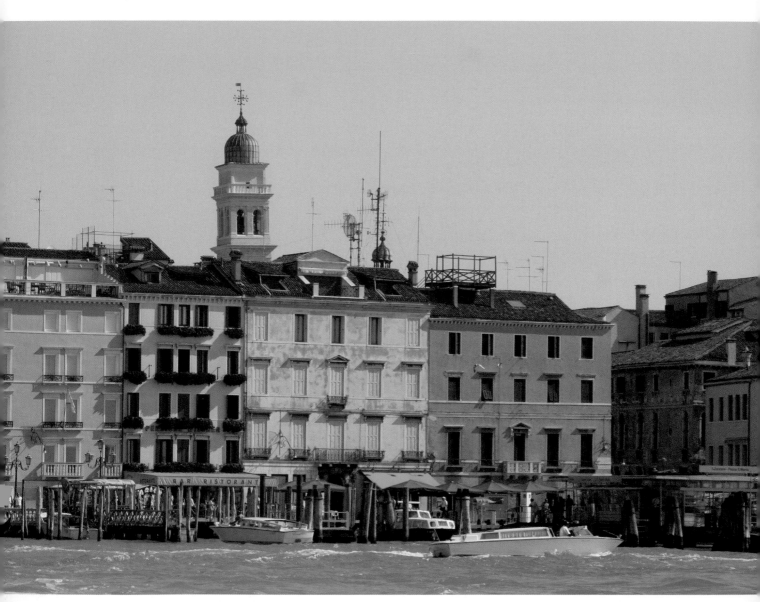

This photograph shows a scene in Venice. I have decided to use a section from this for my painting.

1 VENICE

palette knife with white opaque flakes

Materials used
MDF panel
broad brush
palette knife
clear gesso
pencil
phthalocyanine blue (green shade)
quinacridone magenta
cadmium red light
cadmium orange
cadmium yellow light
titanium white
white opaque flakes

Here I apply clear gesso with a broad brush. The clear gesso is white but dries transparent, somewhat matt.

The drawing.

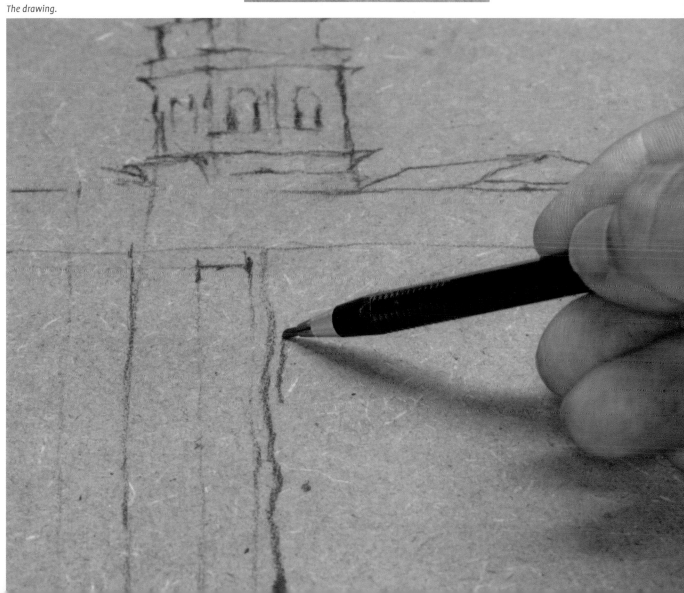

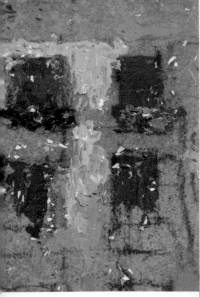

The two detailed
photographs show
that I apply the white
opaque flakes to the
work at an early stage.
Note: if you cover the
surface with paint, the
flakes will, of course,
no longer be visible,
but this can also have
a pleasing effect.

The result.

2 TUTANKHAMEN

transparent technique

Materials used
painter's canvas
flat acrylic brush for wash techniques
palette knife
phthalocyanine blue (green shade)
quinacridone magenta
quinacridone red orange
quinacridone crimson
quinacridone red
cadmium red light
yellow orange azo
titanium white
iridescent medium
glazing medium

This was created during one of my demonstrations.
I applied transparent colours without actually asking myself
what I was going to paint: phthalocyanine blue, quinacridone
magenta and quinacridone red orange layer on layer. I also
incorporated iridescent medium into this. In this way you obtain
a deep, expressive, mysterious ground, which we often find
with the old masters. Every layer that is applied to this makes it
somewhat darker, because the white of the carrying substrate
is obscured more and more, a bit like putting several pairs of
sunglasses one on top of the other. Even sunglasses with lightly
tinted lenses will darken your vision; this is something inherent
in transparent working. It is quite possible that I would leave it
at that and the canvas could, for example, end up in a storeroom
for two years. Here, of course, I am going to continue. I have
decided to use Tutankhamen as my source of inspiration. So now,
I am going to make a start.

*First I apply some
darker accents and
some colour.*

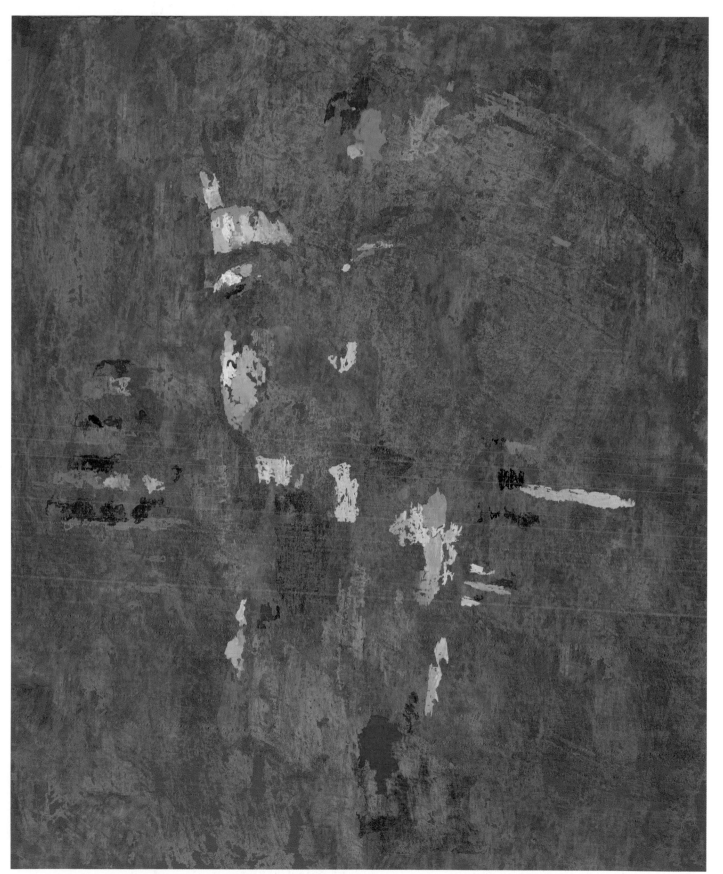

When I apply the lights you can see quite clearly where I am trying to go with this.

3 DOMAINE MAUMONT

ultra matt medium

Materials used
painter's canvas
large brush
palette knife
phthalocyanine blue (green shade)
pyrrole orange
cadmium yellow light
titanium white
ultra matt medium

Phthalocyanine blue (green shade), pyrrole orange and titanium white are mixed on the palette. After this I mix it thoroughly with the ultra matt medium.

My neighbour's house in France, where I give my Dordogne course twice a year.

This time I am going to paint with a large brush.

A first sketch with a brush.

Now I do the underpainting in grey tones. This is a very important part of my teaching: start with greys, and then gradually apply the colours. This type of painting in grey constitutes a foundation for everything that I apply afterwards. This is a very safe way of painting.

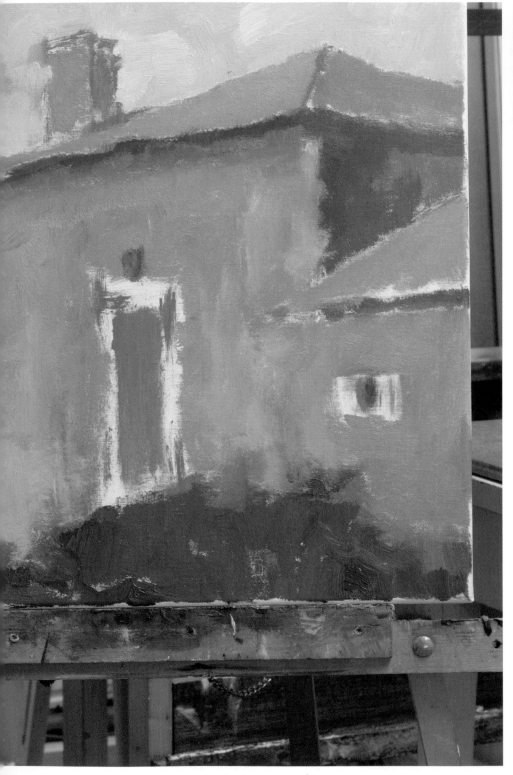

The two illustrations above give some details.

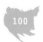

INCREDIBLE ACRYLICS

100

The result on the easel.

4 GIRAFFE

palette knife with flexible modelling paste

Materials used
painter's canvas
palette knife
black gesso
phthalocyanine blue (red shade)
quinacridone magenta
cadmium red light
cadmium yellow light
titanium white
flexible modelling paste

I start here with a black canvas, created with black gesso.

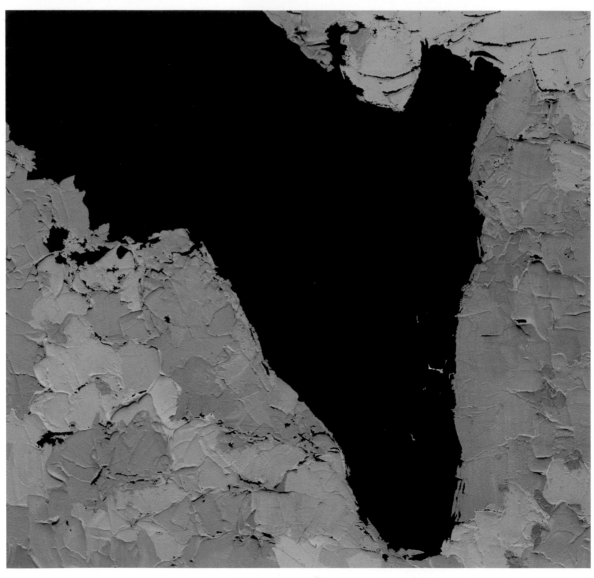

When I apply the background the giraffe quickly becomes visible. However, that does not mean that the background is finished! When I paint the giraffe I may need to adjust the background in some areas.

Here I am beginning to fill in the colours of the giraffe.

The colour structure gradually becomes clear.

Here I apply the relatively purest colours; I always save these for last.

5 STILL LIFE WITH PEAR

transparent technique

Materials used
painter's canvas
pencil
cat's tongue-type acrylic brush
palette knife
phthalocyanine blue (green shade)
ultramarine blue (red shade)
burnt sienna
quinacridone magenta
quinacridone red orange
quinacridone crimson
quinacridone red
yellow orange azo
yellow medium azo
mixing white
airbrush medium
glazing medium

Begin with a simple pencil drawing; then a transparent underpainting to represent the shadow seen on the pear and the ground surface. I start with a mix of ultramarine blue and burnt sienna; this gives an attractive grey tint. I use the airbrush medium to thin the paint for the first layer. I change to glazing medium for the subsequent layers. This is glossy and dries very quickly, so I can quickly carry on painting. Defining the shadow, you obtain the shape; the chiaroscuro or contrast effect is more important than the colour. The other tints applied in the picture opposite relate to the shape and not the colour.

The colours are again gradually built up.

Here I am placing a layer over the background to seat the object in its environment. I am attempting to keep the light side light.

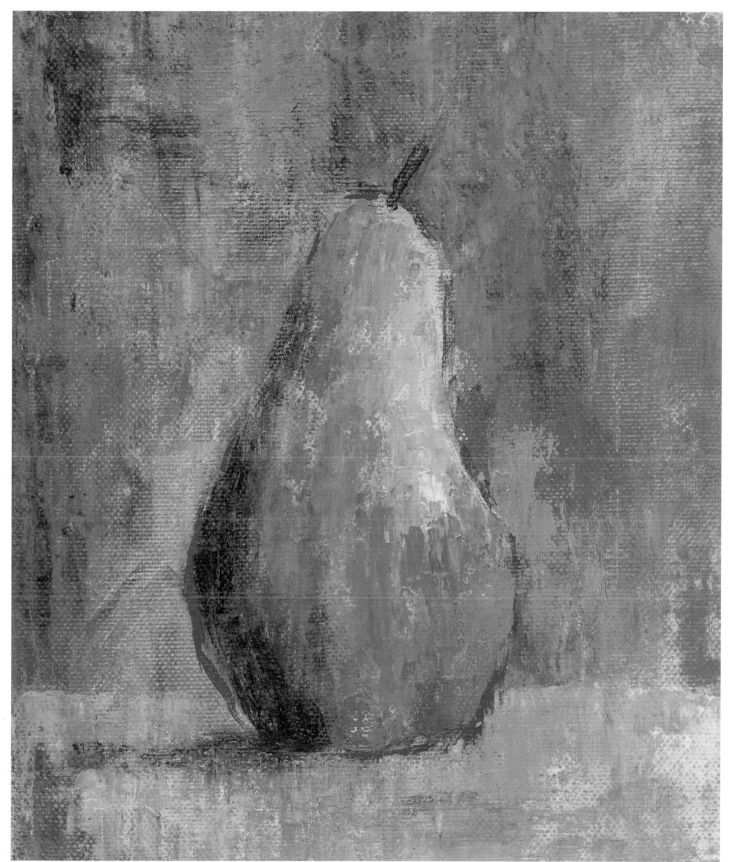

You can work on this painting indefinitely.

The glazing medium, straight out of the bottle.

Spread out generously with a knife.

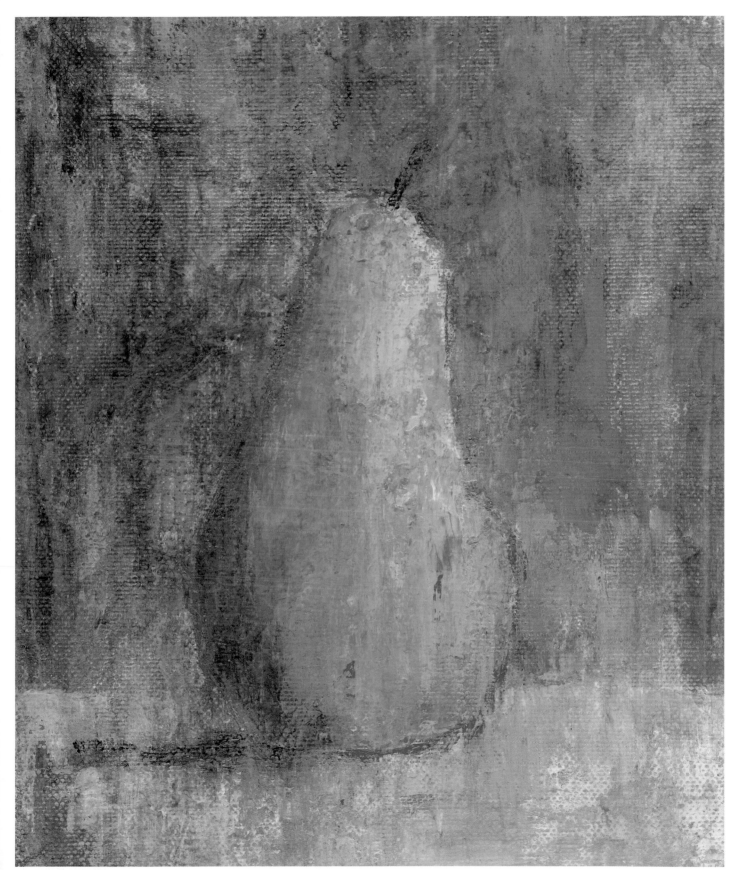

The final result, though the painting could have been considered finished at a previous stage.

6 ABSTRACT

transparent technique

Materials used
MDF panel
super heavy gesso
flat acrylic brush for wash techniques
phthalocyanine blue (green shade)
burnt sienna
quinacridone magenta
quinacridone red orange
quinacridone crimson
quinacridone red
yellow medium azo
airbrush medium
glazing medium

The super heavy gesso.

First layer: burnt sienna, thinned with airbrush medium.

After this, a layer of phthalocyanine blue (green shade).

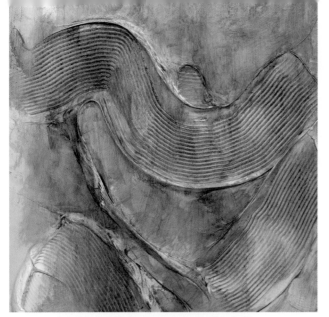

After this I apply quinacridone red orange and quinacridone crimson, thinned with glazing medium.

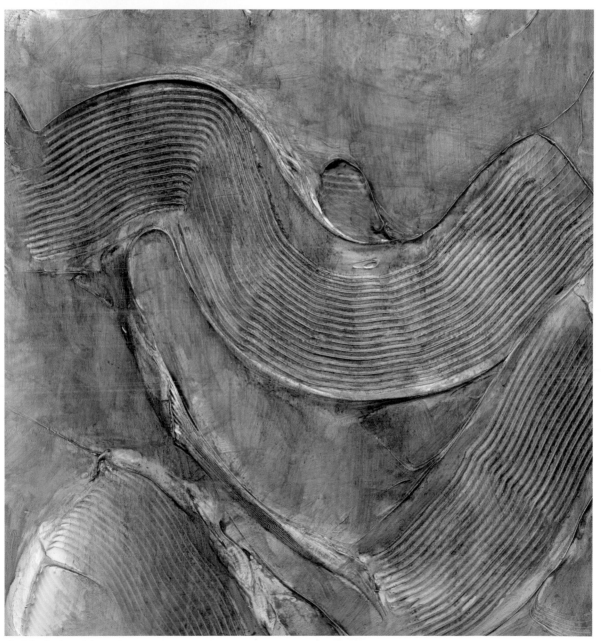

The following layer is burnt sienna.

Quinacridone magenta, quinacridone red orange, quinacridone crimson, quinacridone red and yellow medium azo are placed on top of one another in layers, all of which are, of course, thinned with glazing medium.

This picture shows the detail.

7 UNDER THE BRIDGE IN BRANTÔME

palette knife with ceramic stucco

Materials used
painter's canvas
palette knife
black gesso
phthalocyanine blue (green shade)
quinacridone magenta
cadmium red light
cadmium yellow light
titanium white
ceramic stucco

Here I start with a ground which is applied in black gesso with a palette knife. I deliberately keep the colours grey. The grey colours are composed of phthalocyanine blue (green shade), quinacridone magenta, cadmium yellow light and titanium white.

I continue to work on this phase by painting in the column on the right, always in varieties of grey.

Here I am introducing the first light tones.

Still working in greys!

Finishing off and then adding some red and orange drawn lines.

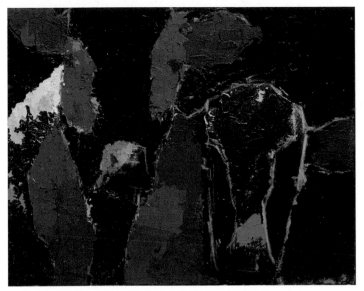

Materials used
painter's canvas
palette knife
black gesso
phthalocyanine blue (green shade)
quinacridone magenta
cadmium red light
cadmium yellow light
titanium white
ceramic stucco
resin sand

A real Dutch landscape: cows. Again working with a black ground, created with a palette knife and black gesso. The first colours are applied, starting with subdued hues. Ceramic stucco is mixed into the first layers. After this I go over it once again with the same colours, but this time mixed with resin sand. This gives it a sense of ageing, maturity. I continue this theme through the remainder of the painting.

I continue to use subdued and therefore greyish colours. This also applies to the parts that look white.

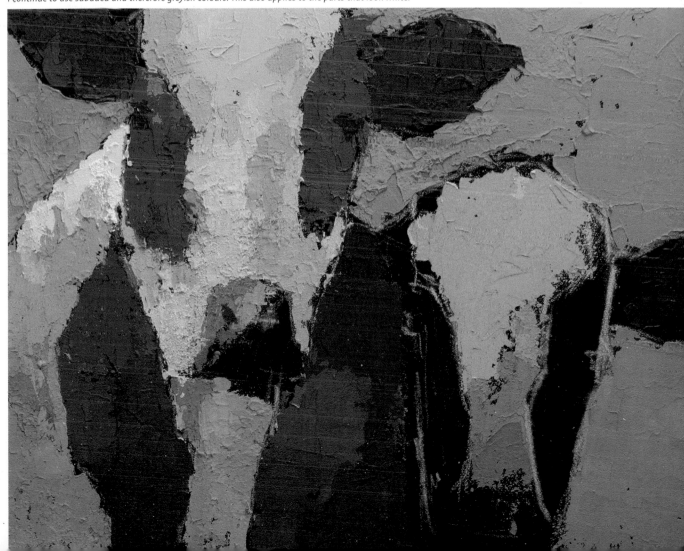

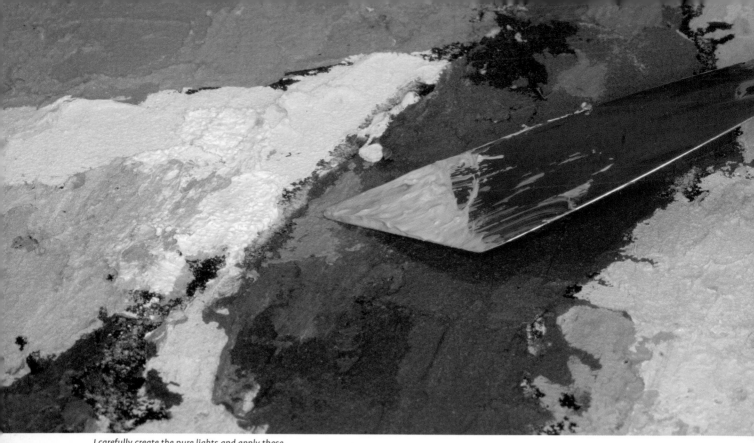

I carefully create the pure lights and apply these.

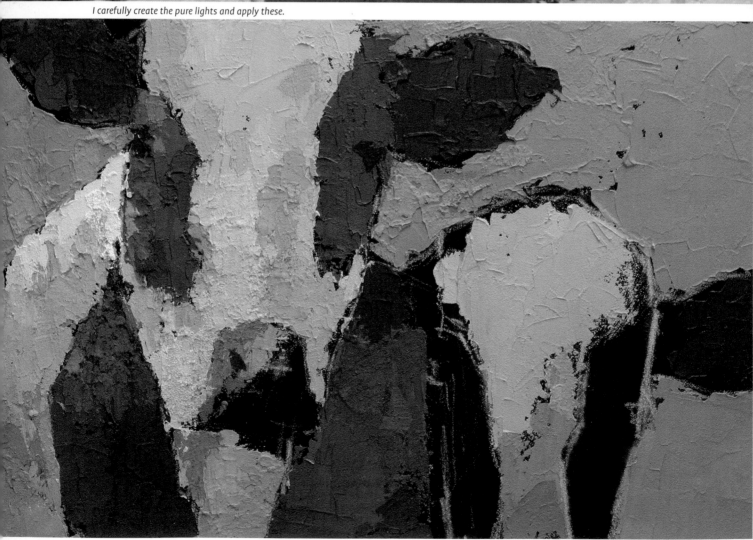

The result. Although not completely finished,
it is nevertheless clearly defined.

9 HARBOUR AT HONFLEUR

palette knife with ceramic stucco and resin sand

Materials used
painter's canvas
palette knife
black gesso
phthalocyanine blue (green shade)
quinacridone magenta
cadmium red light
cadmium yellow light
titanium white
ceramic stucco
resin sand

The harbour at Honfleur.

The working method is identical to that used in Workshop 8, the Dutch cows. I start again with black gesso. The first layers only use ceramic stucco; the following layers only resin sand.

Here I am adding some of the reflections in the water. I continue to observe the sequence of the media.

I spruce up the façades by giving them an extra layer of paint.

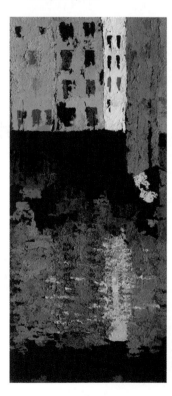

Finishing off: now the awnings, the blue in the water and the boats are painted right at the bottom. The same principle applies here: keep the purest colours for last.

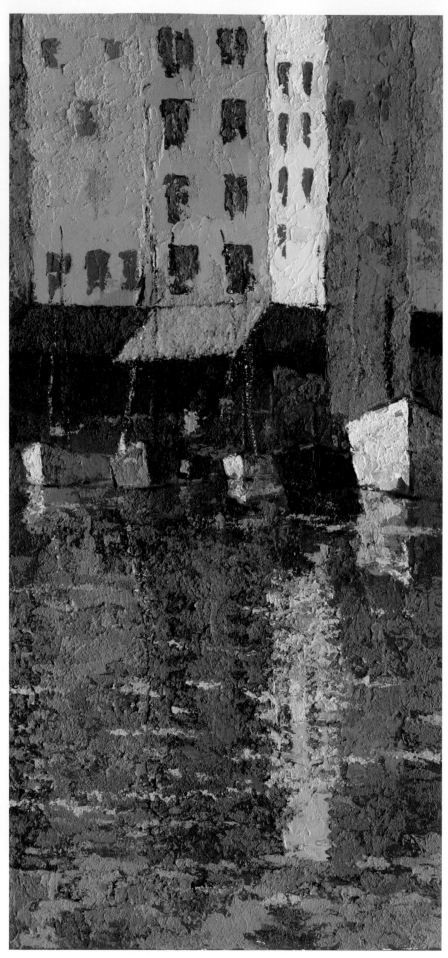

10 EXERCISE IN CUTTING AND PASTING

mixed media

Materials used
painter's canvas
broad brush
palette knife
textured paper
corrugated cardboard
gesso
burnt sienna
phthalocyanine blue (green shade)
cadmium orange
cadmium yellow light
iridescent bright gold
gloss super heavy gel
airbrush medium
gloss medium varnish

Here I am applying gloss super heavy gel to the canvas at the places where I want to paste something: in this case the corrugated cardboard and a piece of paper with a rope texture (at the top of the picture).

Next I stick on both pieces of material and apply a thin layer of gel to the edges and top.

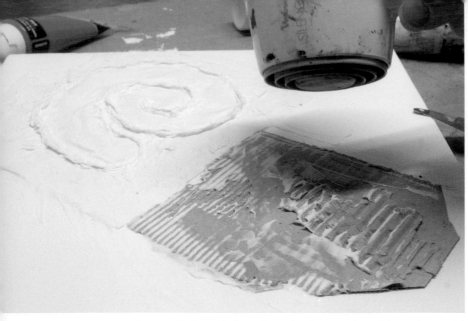

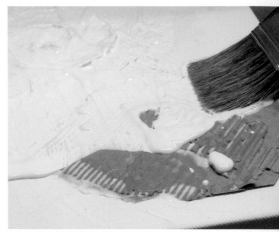

Now I use the hair dryer!

Next I apply gesso. This is to add a layer of ground to the areas where I didn't apply any gel, for when we add a wash later on.

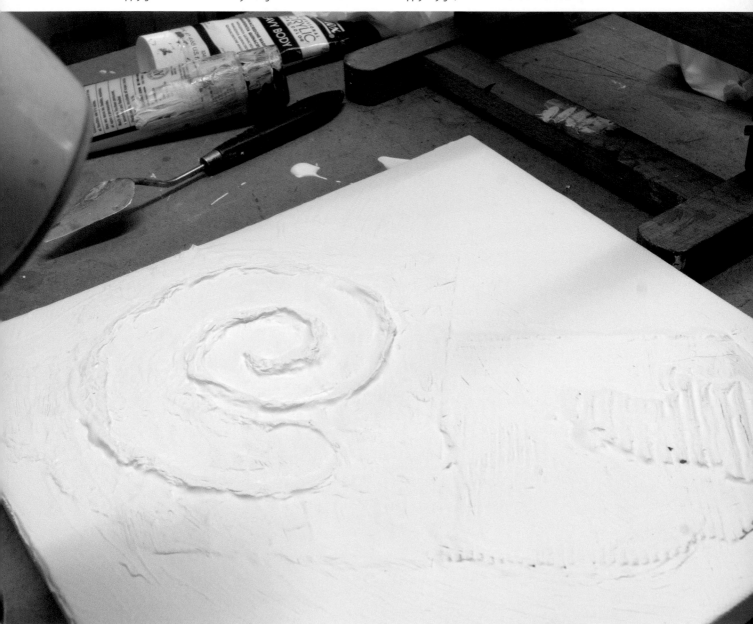

A bit more hair dryer!

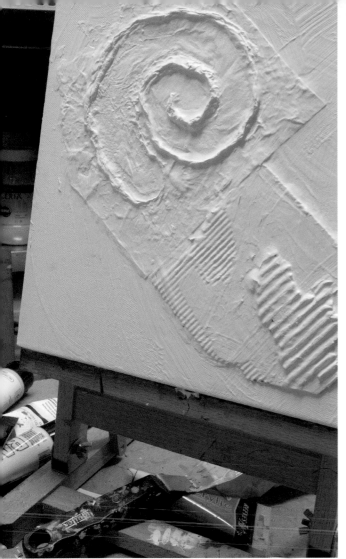

A breather. Here you can easily see the texture you can achieve with this method.

I decide to add some more modelling paste; this is the rough patch at the top left of the corrugated cardboard.

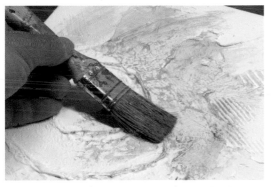

I thin the paint a lot (here the burnt sienna) with airbrush medium. Watch out: do not use water! The paint would really lose its adhesion with such severe thinning. For this reason I use the airbrush medium, which also includes binder medium.

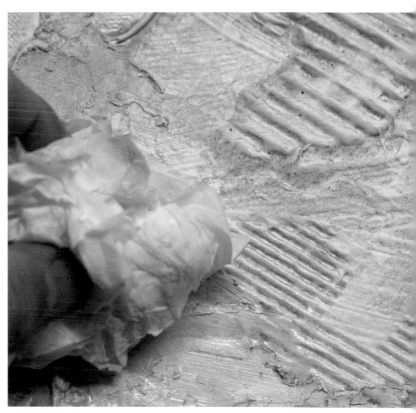

Now I remove the excess with a tissue. This rubs it well into the grooves of the gesso.

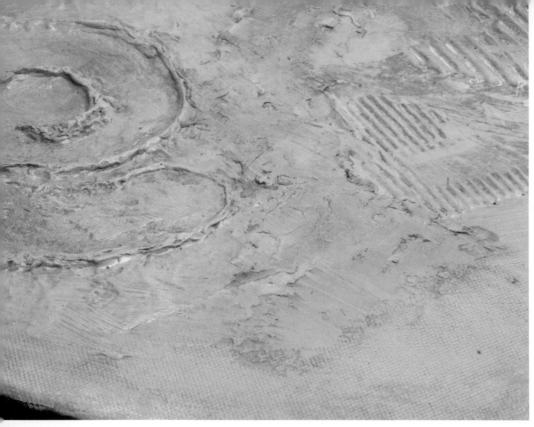

I have chosen phthalocyanine blue (green shade) for the next layer.

In the meantime I am applying a layer of gloss medium varnish.

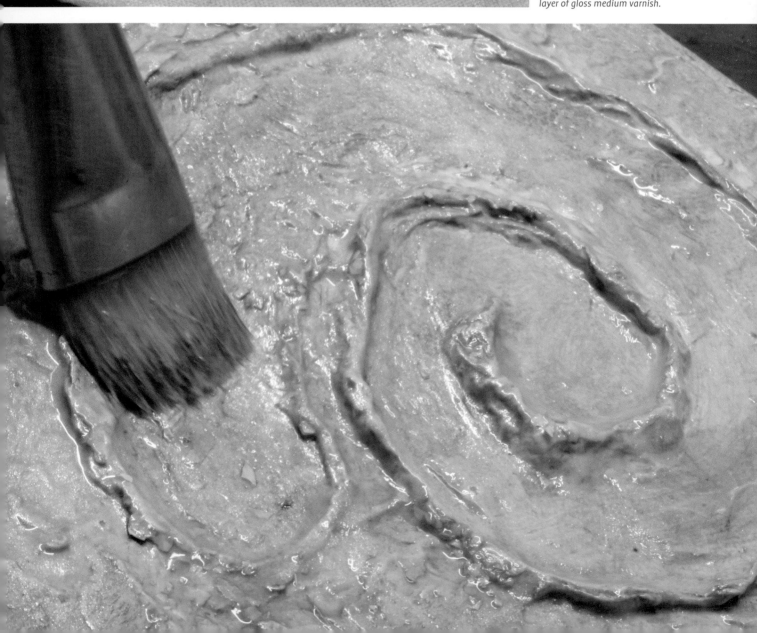

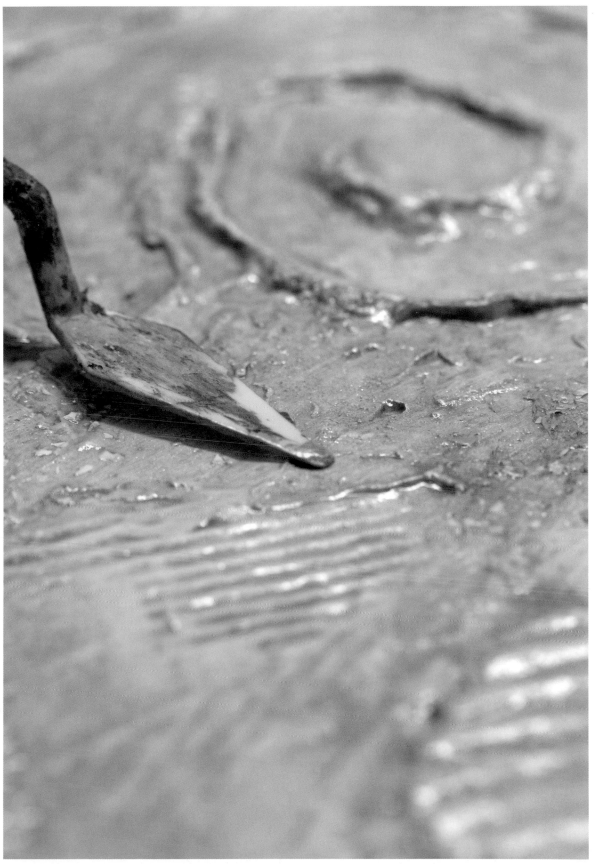

Finally I apply a mixture of cadmium orange with cadmium yellow light and some iridescent bright gold with a palette knife.

11 MONT ST-MICHEL

palette knife with ceramic stucco and resin sand

Materials used
painter's canvas
palette knife
black gesso
phthalocyanine blue (green shade)
quinacridone magenta
cadmium red light
cadmium yellow light
titanium white
ceramic stucco
resin sand

A view of Mont St Michel – an acrylic sketch. The first layers are painted in greys mixed with light modelling paste. Now come the following layers, but worked with resin sand.

Now I work a little on the sky.

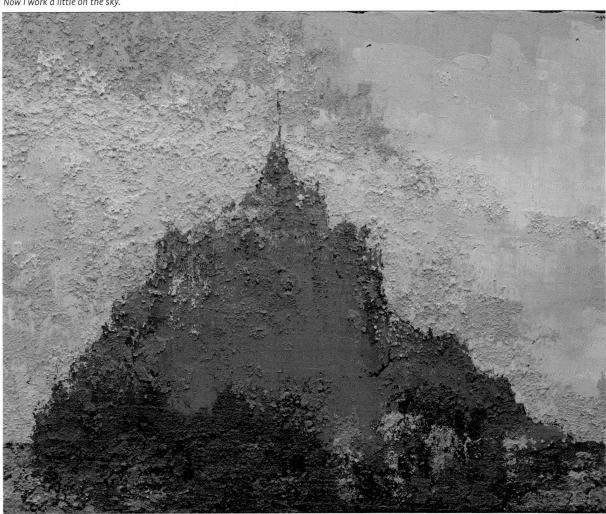

The pure tints, here in orange and yellow, are again kept till last.

I apply highly transparent burnt sienna and phthalocyanine blue (green shade) with airbrush medium to a layer that has already had a lot of gesso applied to it. The grooves made by the brush hairs are also clearly visible, which is the intention.

12 MONKEY

transparent technique with palette knife, iridescent medium and resin sand

Materials used
painter's canvas
broad brush
palette knife
gesso
burnt sienna
phthalocyanine blue (green shade)
quinacridone magenta
cadmium red light
cadmium orange
cadmium yellow light
titanium white
airbrush medium
glazing medium
black lava
resin sand
iridescent medium

After this I define the area I want to keep painting white, again with gesso. This ensures additional texture. I don't yet know which colour I am heading towards, so I just try something at this stage. At the end of the day, a work needs to grow and develop.

All the same, here I go for a somewhat darker background. Between the layers I go over the paint with gloss medium varnish.

These are details which clearly bring out the black lava, the resin sand and the iridescent medium. I almost always apply these with a palette knife.

Here and there I apply some final touches.

13 TREE

palette knife

Materials used
painter's canvas
palette knife
phthalocyanine blue (green shade)
quinacridone magenta
cadmium red light
cadmium orange
cadmium yellow light
titanium white

*In this first stage it is easy to see that I am
again starting with some greys.*

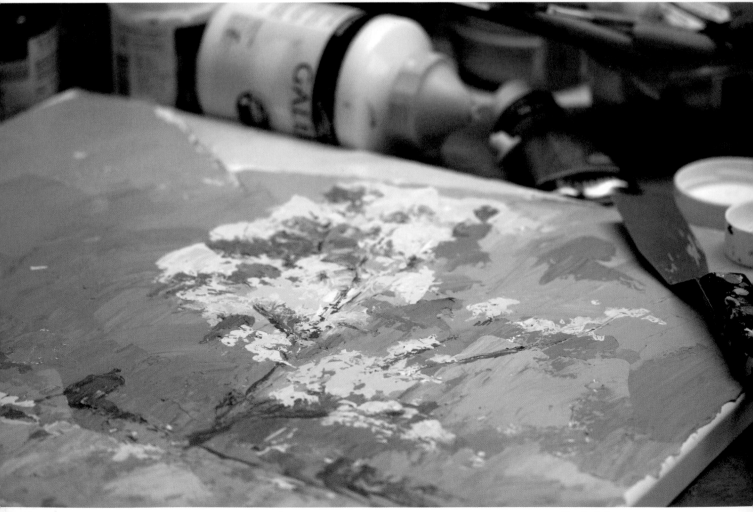

Then let it dry.

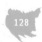

I now add some darker areas to the foliage,
because there are no lights without darks!

Now I add the light areas.

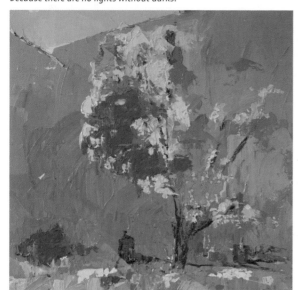 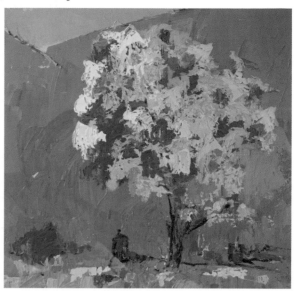

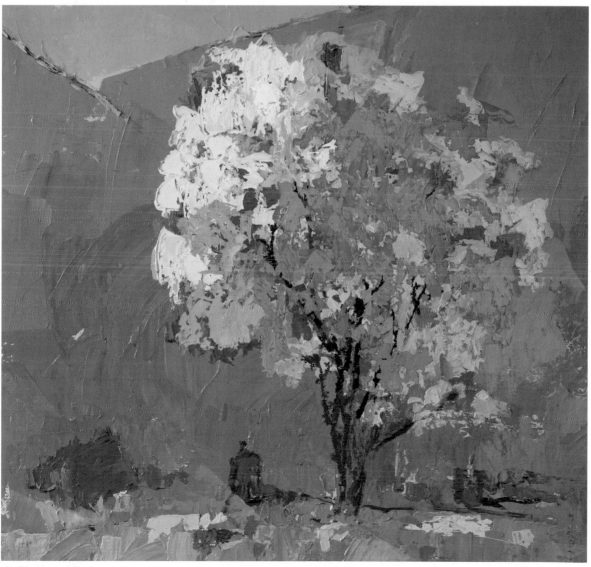

The finishing touches.

The zoo in Emmen.

14 ELEPHANT

palette knife with natural sand

Materials used
painter's canvas
palette knife
phthalocyanine blue (green shade)
quinacridone magenta
cadmium red light
cadmium yellow light
titanium white
natural sand

I lay the painting flat in order to view the effect under a different angle of light. This medium is somewhat reflective.

Here is the first stage, with the familiar greys.

The colours are becoming more intense: see the trunk area.

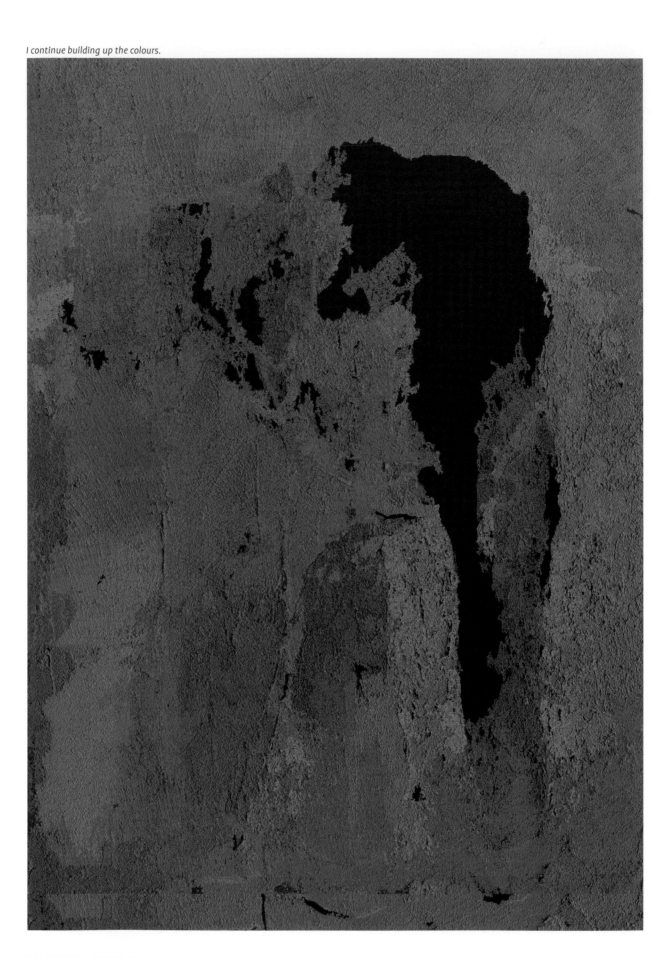

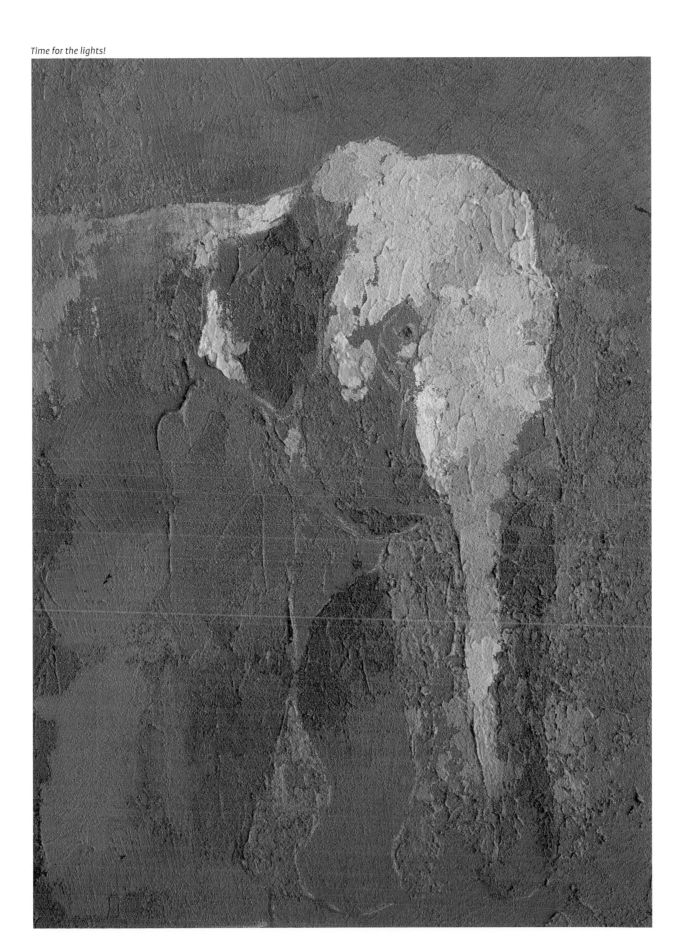

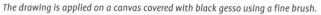
The drawing is applied on a canvas covered with black gesso using a fine brush.

15 LANDSCAPE IN TUSCANY

modelling paste

Materials used
painter's canvas
fine brush
palette knife
cobalt blue
brilliant blue
brilliant yellow green
viridian hue permanent
quinacridone magenta
cadmium orange
cadmium yellow light
titanium white
modelling paste

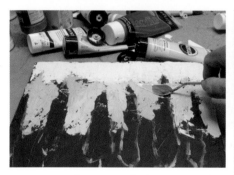

The cypresses also have a part to play.

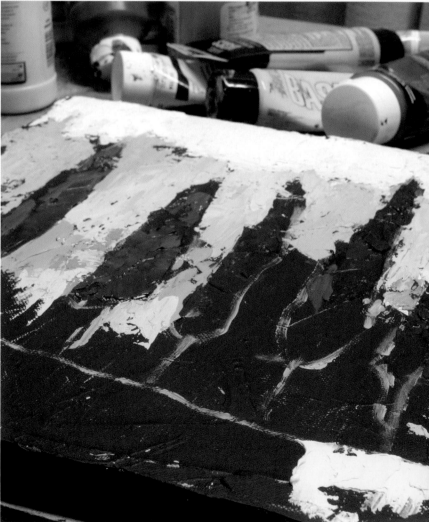

The large areas are applied with a palette knife. The paint has already been mixed with the modelling paste.

This is almost the last phase. The foreground has also been given meaning.

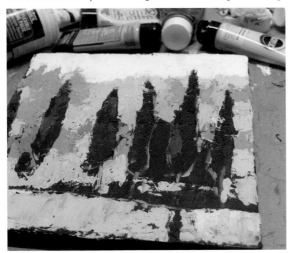

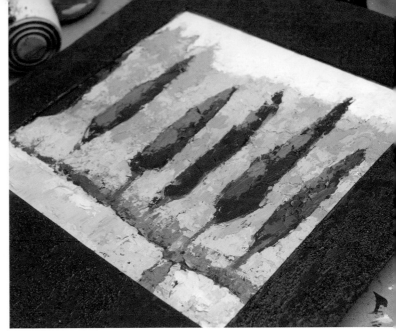

Now I place a mount over the painting, which gives a better view of the work.

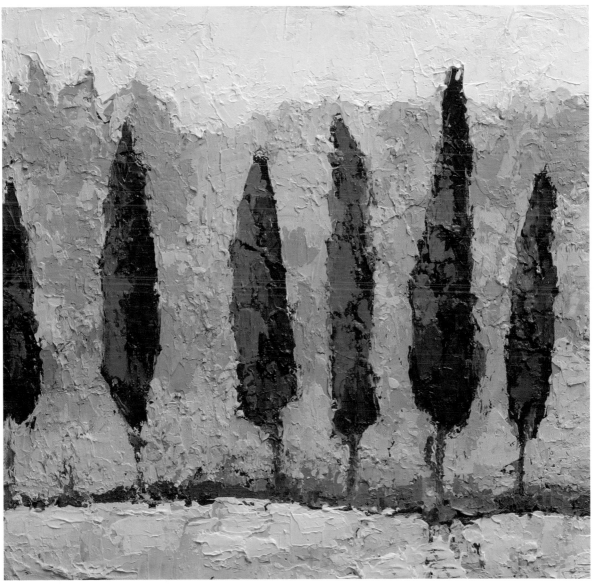

In the final phase I tone down the little path next to the cypress on the right.

16 VENICE

transparent technique with palette knife, black lava, ceramic stucco, iridescent medium and resin sand

Materials used
painter's canvas
broad brush
palette knife
black gesso
burnt sienna
phthalocyanine blue (green shade)
quinacridone magenta
quinacridone red orange
cadmium red light
cadmium red deep
cadmium orange
cadmium yellow light
titanium white
iridescent bright gold
glazing medium
black lava
ceramic stucco
resin sand
iridescent medium

Skin colour! This in itself is a whole journey, which I generally only deal with in a masterclass.
I start here with black gesso (applied with the knife), then a layer of cadmium red deep. Now I am going to apply a wash of iridescent bright gold. Over this I apply burnt sienna with glazing medium. I then do the same with phthalocyanine blue (green shade). The resin sand is also incorporated in its pure form, just as with the black lava.

Grey tints are applied, mixed with ceramic stucco and/or resin sand: see right.

I carry on building up the colours.

In the final phase there is room for pure tints and detail: see the flower boxes. The carefully composed skin colour remains visible in several places. La dolce vita!

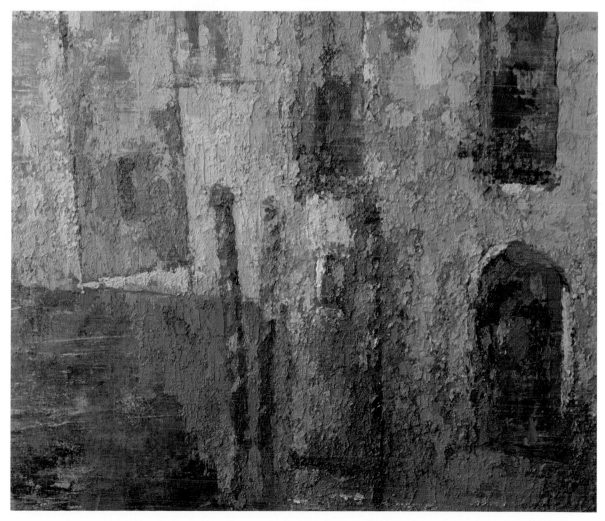

5

Frequently asked questions

Why do different paints have different prices?

The prices of art paints are mainly determined by the price of the pigment. The various pigments derive from different sources and the costs of purification, processing and grinding into paints are extremely wide-ranging.

How can I ensure that the result looks like an oil painting?

Use slow-dry blending fluid or gel to delay drying and to make it easier to mix colours on the base layer or to brush colours into each other. Also use gloss medium. Experiment with glazing techniques.

How can I prevent my paint from drying too fast?

Use as little water as possible, lower the temperature and reduce air currents in the environment where you paint. Use acrylic media that thin the paint (extenders), in particular slow-dry blending fluid or gel, airbrush medium, or slow-dry fluid or gel retarder. Note: only use a single additive in the paint mixture; combining additives can compromise the stability of the paint layer.

My colours look dull and chalky. How can I make them brighter?

You may be adding too much water so that there is insufficient binder in the paint layer. In this case the paint spreads out too much. Try adding gloss medium or blending and painting medium instead of water.

How can I ensure that paint flows like water while retaining its colour intensity?

Use thin professional acrylic paint. You can make this somewhat more fluid with water, but to improve the flow and at the same time maintain the stability of the paint layer, you are better advised to add gloss blending and painting medium, gloss medium or matt medium.

Is water the best thinning medium for acrylic paint?

Water is, in fact, the solvent used in acrylic–water emulsion. You will notice that acrylic paint performs best – and offers the most enjoyment – if you use acrylic media to alter the working characteristics of the paint. Only use water for cleaning purposes.

I have very little money to spend. Where can I make savings?

Professional paints are not cheap. But as with any quality product you get what you pay for. Even so, you can stretch your budget with a couple of strategies: use media to extend the paint and therefore use less of it. If you use ultra matt medium, the composition increases the paint volume without noticeably reducing the intensity of the colour. Also, do the underpainting in student-quality acrylics and restrict the use of professional acrylic paints to the finishing layers.

What is the best ground for acrylic paint?

Acrylic paint is incredibly versatile and can be used for an almost unlimited variety of grounds, including canvas, paper, leather and glass. If you want to work with an unusual ground, then always do an adhesion test first.

What is the best way to prepare a canvas?

Size (seal) the canvas with one layer of matt medium and then add one or two layers of acrylic gesso. Acrylic gessos offer you a choice of traditional white, black, colourless or super heavy gesso.

Why is the surface of my acrylic painting turning to powder, flaking or cracking?

If your gesso or paint layer is chalky (powdery) or unstable, you probably added too much water while you were painting. Water dilutes the acrylic binder, so that the paint layer does not retain the pigment as well. You will notice that you will obtain the best results, and therefore the most enjoyment from painting with acrylic paint, if you use acrylic media to alter the working characteristics of the paint.

Why are some acrylic media milky, others translucent and others crystal-clear when they are wet?

Some acrylic media are milky because of the water in the emulsion. Others contain ingredients that make them matt, so that they appear milky. Other media are made with a clear resin, so they appear more translucent when they are wet than dry.

Why do some acrylic colours dry darker?

In general, a wet acrylic water emulsion is clearly milky in colour. This makes the paint look lighter. When the water evaporates from the emulsion and the binding medium becomes clear, the paint becomes darker. Thanks to advances in acrylic chemistry, the new acrylic resins are somewhat clearer. As a result the colour shift with modern acrylic paints is less drastic than with older acrylic products. It still plays a role with some colours, but not as markedly as before. This phenomenon is most visible with transparent dark pigments such as alizarin and less with light opaque pigments such as cadmium yellow.

What effect does the weather have on acrylic paint?

Humid environments will delay drying. Hot, dry environments will significantly speed up drying. The temperature, air humidity, viscosity of the paint and the absorption capacity of the ground together determine the drying time.

How do I store acrylic paintings?

Protect the surface with cellophane or a sheet of some other non-adhesive material. Place another layer over the cellophane, for example an unprepared canvas. Place the work vertically in an environment where the temperature does not go below 7°C/45°F (the temperature at which acrylic paint becomes brittle and quickly cracks). Never place acrylic paintings with the painted sides against each other, otherwise they can stick together. Always place them in a crate for transportation.

What is the lifespan of acrylic paintings?

If you use sound painting techniques, work on a stable substrate, use artists' quality ground paints and maintain and store them correctly, then acrylic paintings will last for generations.

What is the advantage of making my own paint?

Until 200 years ago, artists had to make their own paint. These days it is not unusual for artists to experiment with making paint in order to gain more insight into the workings of their chosen medium. On the other hand, an experienced manufacturer is in a better position to make paint that involves no risk to the painter; has a higher pigment content; is more uniform; and has better balanced working properties than an individual artist could manage.

Do I need to varnish acrylic paintings?

Yes. The surface of acrylic paint is somewhat sticky and porous after drying, which creates the type of surface to which dust and atmospheric pollution can easily adhere. A final varnish gives the painting a very necessary protective layer. A conservation-quality varnish, such as Soluvar gloss or matt varnish, remains flexible and can be removed at a later stage for cleaning purposes.

...tex

...rials

...X 246

...taway, NJ 08855 U.S.A.

Made in England /

Fabriqué en Angleterre

Distribution in / en Europe

by / par ColArt International

, Le Mans Cedex 2.

283 8300

554050

...X.COM

SOLU...

6

Health and safety

Health and labelling

Working with artists' materials is safer than it has ever been. In Europe and North America there are instructions on all product labels for safe use, but with most products no warnings are necessary. With products that do need safety warnings, there is detailed information about risk-free working methods. Always read the product labels first. There are instructions on all labels on artists' materials for safe use.

How safe are the products?

Working with art products Is safer than ever before. In recent decades new generations of pigments, carriers (vehicles), sizes and other raw materials have been selected because they offer the optimum potential for the end product, but also because they are not toxic. You can use products and enjoy them with the full confidence that they present the minimum possible risk. Where products do constitute a potential risk, publications and labels provide the most recent information about health and safety. It is, in any case, always best to handle these materials carefully and with respect.

Tips for a safe studio

Borrowed with the permission of the author from *What Every Artist Needs to Know About Paints and Colours*, by David Pyle, Krause Publications, © 2000.

When working

- Always make sure that there is plenty of fresh air and ventilation, especially when working with solvents.
- If you are spraying a product, wear an approved mask. A spray booth or, even better, an extraction system vented to the outside is recommended.
- If working with powdered pigment, the above provisions for ventilation are even more important.
- Always keep all materials, especially solvents, tightly sealed. This means keeping the threads on lids and jars wiped clean, to ensure a better seal when closed.
- Art materials should never be exposed to heat sources or to naked flames.
- Do not eat, drink or smoke when working. You never know what may end up on your fingers, your food or your cigarette, and then get swallowed inadvertently.
- Avoid skin contact, particularly with solvents. Do not paint directly with your fingers.
- Do not wash or rinse brushes in the palm of your hand. Doing so, particularly if they are laden with solvent, is a particularly efficient method for driving pigment into and through the skin.
- When washing brushes, palettes or other tools, first wipe them free of colour with a paper towel. If using stiff brushes with thick colour, like oils or acrylics, an old toothbrush works well for scraping free excess colour. Allow the product on the towel to dry completely before disposal.
- Wash off watercolour or acrylic paint with water.

- Wash brushes with a mild conditioning soap.
- Never store brushes resting in a container with the bristles pointing down.
- Do not put your brushes in your mouth. Swirl the brush in a cup of water, or solvent, to check the point.
- Send excess solvents to the local recycling centre or waste processing company.
- Prevent groundwater pollution by never flushing oil or acrylic paint or solvents down the drains or the toilet. The same applies to lead-based paint.
- After finishing painting with acrylic paint, first allow excess paint and kitchen paper to dry completely, so that the dried polymer vehicle to some extent fixes the pigment. This minimises the risk of it dissolving in rubbish or waste water.
- If for some reason solvent is splashed into your eyes, wash them immediately and thoroughly with cold water.
- Clean up all spills immediately.
- Keep art materials out of the reach of children, unless the label states that the material is safe for use by children. Because children are smaller and weigh less, art materials are more dangerous for children than for adults.
- Wash your hands when you have finished and remove any paint or other residues from your hands with kitchen paper. Use a good soap or hand cleaner to clean your hands thoroughly.

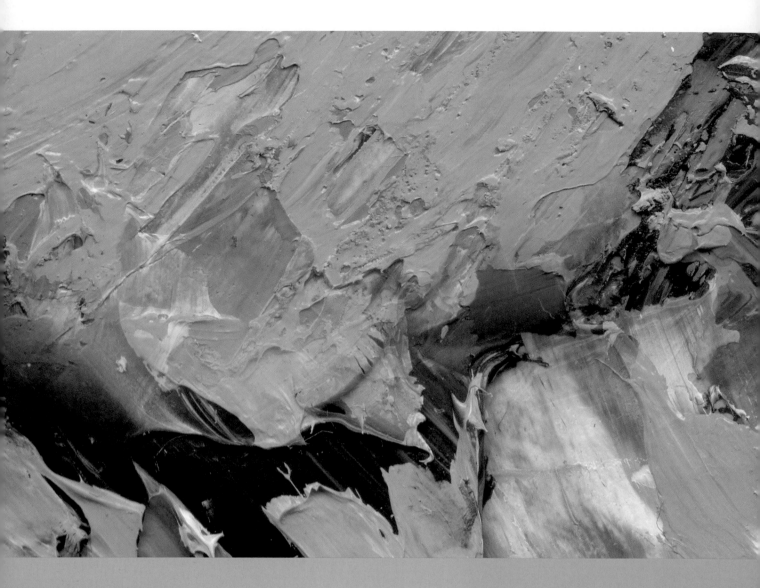

7

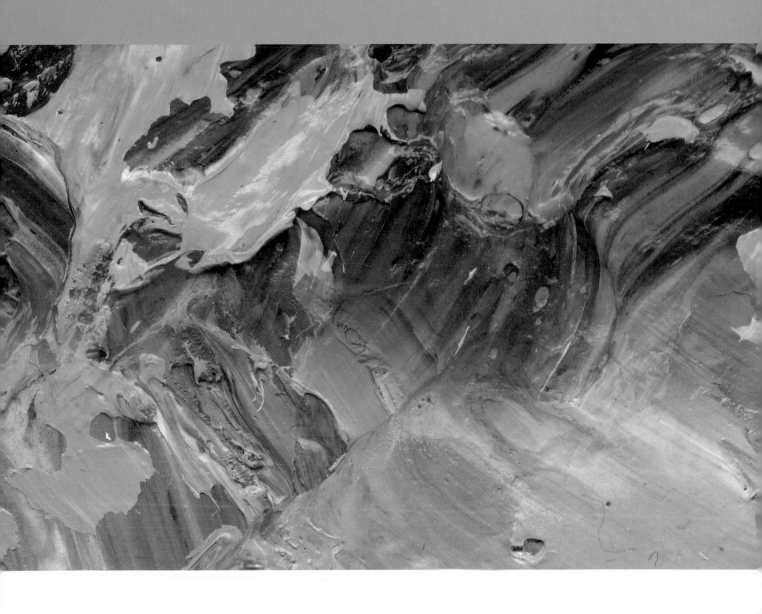

Colour cards

light portrait pink opaque	810	
medium magenta opaque	500	
deep magenta semi-transparent	300	
quinacridone magenta transparent	114	
alizarin crimson hue perm. transparent	116	
cadmium red deep hue opaque	311	
quinacridone red orange transparent	109	
pyrrole crimson opaque	326	
quinacridone crimson transparent	110	
quinacridone red transparent	112	
naphthol crimson transparent	292	
pyrrole red opaque	321	
cadmium red medium hue opaque	151	
cadmium red medium opaque	154	

naphthol red light transparent	294
cadmium red light opaque	152
cadmium red light hue semi-transparent	510
pyrrole orange semi-transparent	323
vivid red orange transparent	620
cadmium orange opaque	150
cadmium orange hue semi-transparent	720
red oxide opaque	335
burnt sienna opaque	127
transparent burnt sienna transparent	129
quinacridone burnt orange semi-transparent	108
Van Dyke red semi-transparent	392
burnt umber opaque	128
transparent burnt umber transparent	130

	raw umber opaque	331		cadmium yellow light opaque	160	
	transparent raw umber transparent	333		cadmium yellow light hue opaque	159	
	raw sienna opaque	330		Hansa yellow light transparent	411	
	transparent raw sienna transparent	332		brilliant yellow green semi-transparent	840	
	Indian yellow semi-transparent	324		vivid lime green opaque	740	
	yellow orange azo transparent	414		light emerald green opaque	650	
	cadmium yellow deep hue opaque	163		light green permanent opaque	312	
	naples yellow hue opaque	601		emerald green opaque	450	
	yellow oxide opaque	416		green gold semi-transparent	325	
	bronze yellow opaque	530		chromium oxide green opaque	166	
	Turner's yellow semi-transparent	730		sap green permanent semi-transparent	315	
	cadmium yellow medium hue semi-transparent	830		Hooker's green hue permanent semi-transparent	224	
	cadmium yellow medium opaque	161		green deep permanent opaque	350	
	yellow medium azo transparent	412		viridian hue permanent opaque	398	

transparent viridian hue 327
semi-transparent

Hooker's green deep hue perm. 225
semi-transparent

phthalocyanine green 319
(yellow shade)
transparent

phthalocyanine green (blue shade) 317
transparent

cobalt green 171
opaque

cobalt turquoise 169
opaque

turquoise deep 561
semi-transparent

cobalt teal 172
opaque

bright aqua green 660
opaque

light blue permanent 770
opaque

brilliant blue 570
opaque

cerulean blue 164
opaque

cerulean blue hue 470
opaque

manganese blue hue 275
opaque

cobalt blue 170
opaque

cobalt blue hue 381
opaque

Prussian blue hue 320
semi-transparent

ultramarine blue (red shade) 382
opaque

ultramarine blue (green shade) 380
semi-transparent

phthalocyanine blue (red shade) 314
transparent

phthalocyanine blue (green shade) 316
transparent

indanthrene blue 322
transparent

light blue violet 680
opaque

brilliant purple 590
opaque

prism violet 391
transparent

deep violet 115
semi-transparent

quinacridone blue violet 118
transparent

dioxazine purple 186
transparent

ivory black opaque	244	
mars black opaque	276	
Payne's gray opaque	310	
neutral gray value 5/mixing gray opaque	599	
transparent mixing white transparent	430	
unbleached titanium opaque	434	
parchment opaque	436	
titanium white opaque	432	
iridescent white transparent	238	
iridescent bright gold semi-transparent	234	
iridescent rich gold opaque	235	
iridescent antique gold opaque	237	
iridescent bright silver semi-transparent	236	
iridescent rich silver opaque	239	

iridescent rich copper 230
opaque

iridescent rich bronze 229
opaque

8

Painting
accessories

Painting knives

Increasingly, artists are working with all manner of materials. Thus there is a call for different types of painting knives.

BLUNT PAINTING KNIVES

These flexible and blunt-ended, extra-long painting knives are springy and therefore perfect for mixing and applying paint, gels, modelling paste and various other impasto materials in thick layers. This type of knife is suitable for applying large quantities of paint and gels on a canvas or panel for a rich impasto.

ANGULAR PAINTING KNIVES

These are flexible trowels with rigid, rounded corners, just springy enough to be used for perfect mixing and spreading of paint, structure gels and various other materials. With these painting knives you can easily move large quantities of paint and structure gels over the surface being worked on. They can be used to create shapes, to model with or to fashion raised surfaces, as well as removing thick paint layers.

'SCRAPER' PAINTING KNIVES

The strong stiff blade of this painting knife is springy and perfect for 'scraping' techniques, or grattage, but also for mixing and applying one level of paint and gel on top of another. The long handle protects your hands and knuckles, so there is no unwanted contact with the support on which you are working. These painting knives give you the freedom to add paint one layer upon another, and to remove existing paint in thick layers. In addition, they are very suitable for sculpture-type painting techniques, for example with super heavy body acrylics and extra heavy gels.

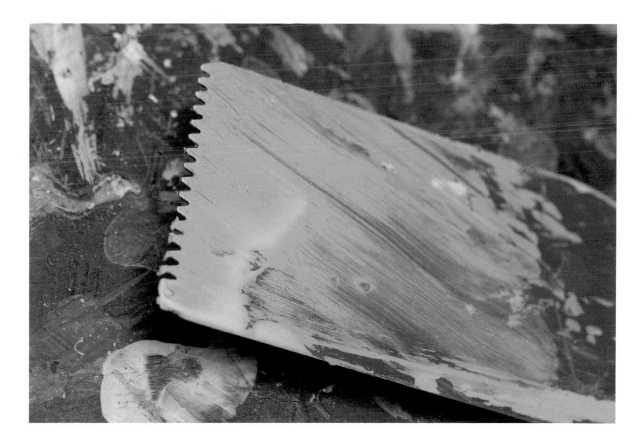

Stretched painters' canvases

Painters' canvases have become far more popular in recent years. This is thanks to better quality canvases now available in Europe, and the constant improvement in Chinese products, and because shops which until 2002 only sold shampoo, lawnmowers or toys are now offering canvases for sale.

Painters' canvases in fact consist of three components:
- a wooden frame or stretcher
- a canvas stretched over the wooden frame
- a primer/adhesive layer applied to the canvas

THE STRETCHER

The wooden stretcher consists of four lengths of wooden slats or laths, connected to each other with dovetail joints. This is a no-glue, tight and permanent connection. The thickness of the wood determines the stiffness of the stretcher. With larger dimensions the stretcher will be reinforced with cross-members (a lath mounted at right angles fixed with a dowel pin) or even with a diagonal lath (laths that are mounted crosswise on the stretcher frame). To guarantee the rigidity of the canvas, it is important to make sure that the wood in the stretcher frame will not warp from the time of manufacture until many years after painting. This rigidity is mainly determined by the drying of the wood during the period preceding the manufacture of the stretcher bars. Where the moisture content of the wood is low enough (12 per cent or less) subsequent twisting is virtually impossible. This is certainly true if high-quality pine is used. In addition, wood with an even structure – and therefore with fewer knots – is less likely to twist.

Countries such as Austria, Poland and the Ukraine supply top-quality pine. Wood with an FSC label is no better than wood without this label. The FSC label only guarantees that the wood has come from responsibly managed forests: there is no excessive logging and every tree is replanted. Both separate laths and stretched frames have projecting beaded edges to limit contact between the canvas and the wood.

As well as solid wood frames, there are also frames available that are reinforced with aluminium. These stretcher bars are only useful if they exceed a length of two metres. With smaller lengths the twisting of the wood is too negligible to justify the high cost of the aluminium.

THE CANVAS

A number of years ago linen was the only reliable support for painters. There were various reasons for this. Oil paint was the most commonly used type of paint. After drying, oil paint has a maximum flexibility (shrink–stretch factor) of 4%. Cotton – which mainly came from Italy at the time – was far more flexible, therefore using oil paint on cotton was a pointless exercise. Almost all linen at the time came from Belgium. Belgian flax was the raw material for linen and was considered the best in the world. Currently this distinction belongs to Czech and also to Polish flax. The harsher climate in those countries ensures a more stable product. Linen can be bought on a frame either unprepared or prepared: more about this later.

Cotton is now the most commonly used support for painters. The quality of cotton has improved in recent years, and even cotton from China and India is of quite acceptable quality, certainly when using acrylic paint. Cotton is still not quite as dimensionally stable as linen. In the case of rayon cotton, gossamer-fine synthetic fibres are woven into the cotton. All the specific properties of the cotton are retained, but this process reduces the flexibility of the cotton to less than 4 per cent and makes it suitable for oil paint. Ideal rayon cotton has a minimum weight of $320g/m^2$.

If you have a choice, I advise you to use unbleached cotton. Bleaching cotton always has a negative effect on the cotton. Unbleached cotton doesn't look as polished, but with a good layer of primer you won't see the difference in colour anyway.

THE PRIMER

It is in fact impossible to paint directly on linen or cotton. Both materials are off-white, are very absorbent and, because most artists' paints are largely transparent, the colours will not show their true characteristics. Unprepared cotton and linen are also available, but this is more so that the artist can himself decide on the preparation. The preparation involves applying a white layer on the canvas to which the paint can stick. It also increases the quality of the canvas: less shrinkage, less slackness, therefore a stable and tighter canvas. A coating of size is first applied to the unbleached linen and cotton: rabbit glue was traditionally always used for this purpose. In Belgium this was replaced by hide glue a long time ago. This is regrettable and certainly not necessary, because Polish linen is in fact treated with real rabbit glue. Rabbit glue provides the most natural approach, and is suitable for linen. Cotton is almost always prepared with synthetic sizes. Synthetic sizes make the canvas virtually 100 per cent waterproof, while it can still continue to breathe. The ground is applied after the size layer has been applied and dried. This layer is also called primer or gesso. The ground can consist of a mixture of acrylic polymer medium and titanium white. This is the product that you can buy under the name of gesso. This mixture makes the canvas suitable for all techniques after it is dried: oil, alkyds and acrylics.

STRETCHING

Traditionally, canvases were always attached to the sides of the stretcher with nails. Since nails were temporarily replaced with staples, virtually all canvases are now fixed to the back of the frame with staples. This allows artists to paint the side of the canvas and to present the piece without a surrounding frame, while the canvas must be sufficiently pulled over the back to enable it to be re-stretched.

PAINTING CARD

You can also choose to paint on a special type of card. This type of card, which generally weighs more than $500g/m^2$, is produced by compressing various layers of moist paper. Pure rag paper is almost unobtainable now, and almost no painter would want to pay for it. The present-day types of card are made of a large amount of paper and few rags. It is already sized and usually features a linen weave texture on one side. It is important that the card is prepared in the same way on both sides to prevent it from warping.

Essentials when painting with acrylic paint

- A minimum of three primary colours with black and titanium white, with the emphasis on minimum; see also under 'palettes'.
- Brushes.
- Whitewash brush to apply gesso to larger panels.
- Palette knives or painting knives; these can be used interchangeably.
- A (tear-off) palette.
- Media. In every case a gloss or a matt liquid medium. For example, flexible modelling paste and gloss super heavy gel medium. You can do anything with the latter: thicken the paint, or make it more transparent and glossier. It is also very useful for collage techniques. You can even glue lead into the painting with this. You should, however, avoid using water to thin the paint.
- Rags to clean knives and/or brushes.
- A hair dryer.
- Painters' tape and clamps.
- A knitting needle to align your work when drawing and to take measurements.
- An easel. It is necessary to place the work vertically in order to view it from the most logical direction – straight in front of you.

Index